Boston Harbor

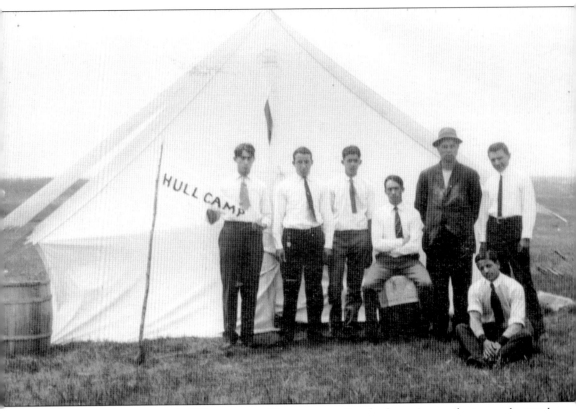

Postcards from the early 20th century offer opportunities for historians to better understand what the people of the Boston Harbor region did for work and play that did not necessarily get recorded otherwise for the historical record. Whether one was tenting out with some friends on Peddocks Island off Hull, or testing out a new naphtha launch off Hingham, or spending a summer Sunday with the family on Revere Beach, or taking a ride on the Boston, Revere Beach and Lynn Railroad, commonly known as the "Narrow Gauge," in Winthrop, Boston Harbor had much to offer the early-20th-century resident or visitor. Through the more than 200 postcards printed in this book, the authors hope to transport you back to a time of high energy and enthusiasm for recreation and industry in Boston Harbor.

On the front cover: Please see page 107. (Courtesy of William and Elaine Pepe.)

On the back cover: Please see page 11. (Courtesy of Rodney Brunsell.)

POSTCARD HISTORY SERIES

Boston Harbor

Donald Cann and John Galluzzo

ARCADIA
PUBLISHING

Published by Arcadia Publishing
Charleston SC, Chicago IL, Portsmouth NH, San Francisco CA

Printed in the United States of America

Library of Congress Catalog Card Number: 2005937495

For all general information contact Arcadia Publishing at:
Telephone 843-853-2070
Fax 843-853-0044
E-mail sales@arcadiapublishing.com
For customer service and orders:
Toll-Free 1-888-313-2665

Visit us on the Internet at http://www.arcadiapublishing.com

To all who work on, play in, and love Boston Harbor.

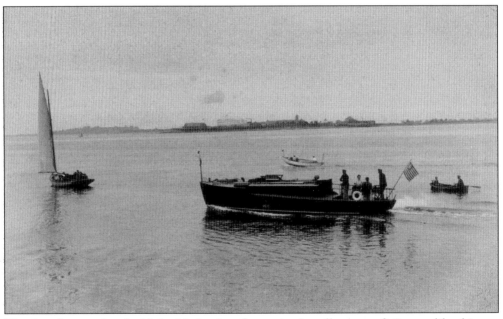

The rise of postcards coincided with the rise of motorized small watercraft. Images like this one reflect the newfound fun of such boats in places like Hingham Harbor.

CONTENTS

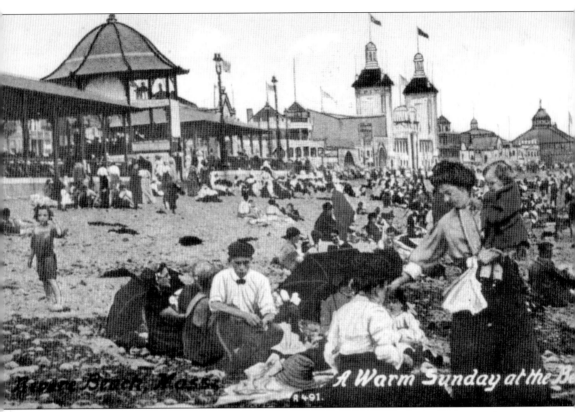

Postcards of the early 20th century captured the final days of the morals of a rigid Victorian America. As the age of postcards moved forward, scenes like this one on Revere Beach featured less and less fabric in the average person's beach attire.

INTRODUCTION

The history and anecdotes of Boston Harbor have been told in many books and articles. Maritime historian and storyteller Edward Rowe Snow may not have started the trend with *The Romance of Boston Bay,* published in 1944, but he certainly was the first to truly interest people about the subject. Our postcard history of the harbor is a similar "snapshot" of this history and romance of the harbor in the first part of the 20th century, but with approximately 200 picture postcards, the authors' intention is to open a more thorough visual window into that time. We hope to bring the reader into a period when things were changing for the harbor and for the people who lived on and near the waters of Boston Harbor.

We have set our bounds to the north, the town of Nahant, and, to the south, the town of Hull. The bound to the east is the position where the Boston Lightship was stationed and to the west, the mouths of the Charles and Mystic Rivers. We have also included the shorelines of the towns and cities that surround the harbor. This brings us into the bays of Dorchester, Quincy, and Hingham, the shoreline of Winthrop, Broad Sound, and the beach at Revere. Besides the picturesque, the postcards' views give a glimpse of a working harbor, recreation, long-ago storms, ships, and even the once all-pervading military presence within the harbor.

The period between 1900 and 1915 is considered the heyday of the postcard; the concept was new and almost any subject was game for a picture to be sent. This was the time when the mail was delivered twice a day and the postcard was the instant message of its time. Affordable cameras were available and people could even make their own unique postcards, known as real-photo cards. Today, this type of postcard is highly regarded by collectors and historians alike. Enterprising small businessmen of the day published real-photo postcards as well, hoping to cash in on the trend; they, while not necessarily as rare as the homemade versions, are also highly regarded for their content. Nevertheless, the subject matter is what makes the difference. The historical cards depict events: the launching of a ship, a wreck on the beach, or any other occurrence. The standard view card, more prevalent at card shows today, depicts a seascape, the fishing boats at T Wharf, or an amusement park at the beach.

The historical and the view cards are the styles of card chiefly used in this book. After World War II, the local postcard virtually disappeared. The novelty was gone, and the ability to travel more conveniently made this product unprofitable. Yet, Boston remains a destination, and postcards of the harbor are still being published. They, too, will be collected, perhaps to turn up in a book similar to this one some time in the future.

Census records show Boston's population in 1900 was nearly 600,000, and it increased to about 800,000 in the 1950s. Our study is of a time of general prosperity. It is a time of immigration

from eastern Canada and Europe, especially the Mediterranean region. We see harbor activities prior to World War I, when flight was a novelty and commercial sail still had a niche in the business of the harbor. During this period industries such as textiles and shoes were still putting the people of greater Boston to work.

The summer cottages, the beaches, and the Victorian resort were all are part of summer life in the harbor in the early 20th century. We hope this book brings to the people of the early 21st century a picture of Boston Harbor enjoyed by the people of the region 100 years ago.

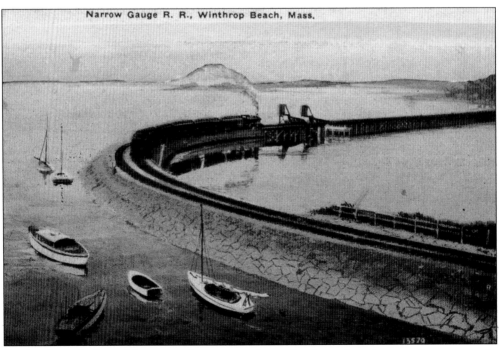

Narrow Gauge R. R., Winthrop Beach, Mass.

During the early days of the postcard, transportation on land was changing as trains gave way to automobiles. The Boston Harbor of the postcard era is a distant ancestor of the Boston Harbor of today. Some aspects of everyday life remain, but others have changed forever.

One

THE APPROACH TO BOSTON HARBOR

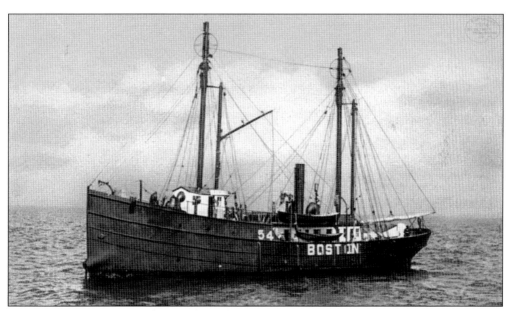

Visiting Boston Harbor, for many folks in the heyday of the American postcard, meant traveling by water. And that certainly sounds delightful. The steamboats of the day were opulent, well-appointed and a symbol of the good life in late-Victorian New England. But the approach to Boston was not necessarily a safe and simple route. Lighthouse Channel, which runs between the Brewster Islands and the northern reaches of the town of Hull, is narrow, winding, and not always deep. Many lighthouses and other aids to navigation helped sea captains heading for the city find their way, and all of those lighthouses, picturesque as they are (or in some cases, were, like the Boston Lightship, pictured here, six miles east of Boston Lighthouse), became quickly collectible on postcards published in the region.

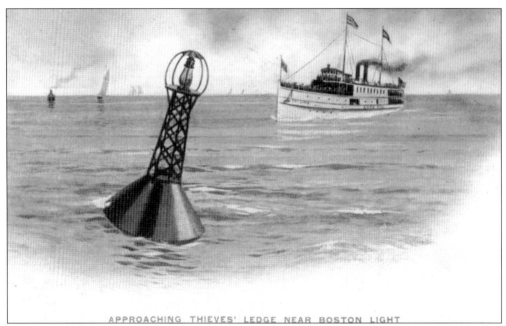

About three-and-a-half miles west of the Boston Lightship and two-and-a-third miles east of Point Allerton, Thieves Ledge is today a popular fishing location, but in the days before lighthouses, it was as treacherous a spot as there could be for mariners on the east coast.

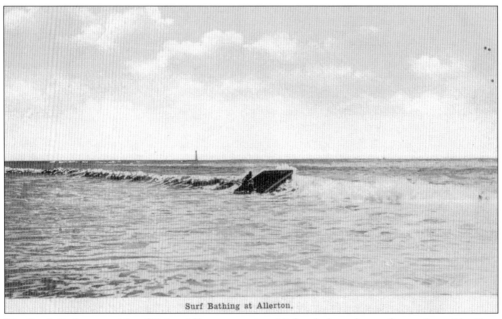

Surf Bathing at Allerton.

Harding's Ledge, outside of Point Allerton, sat just 10 feet below the surface at low tide. But, by lining up the red fixed light of Narrows Lighthouse below the beacon at Long Island Head further in the harbor, one could confidently sail on, knowing they were north of the ledge and no longer in harm's way. Alas, though, as indicated by the popularity of Harding's Ledge as a recreational dive site, many ships met their doom before reaching the harbor.

Although south of the entrance to Lighthouse Channel, Minot's Light, warning of the rocky ledges off the Scituate and Cohasset coastlines, held a special flash pattern at the beginning of the 20th century when this postcard was produced. Its lens flashed once, paused, flashed four times in succession, paused again, and flashed three more times. Romantics soon interpreted the "1-4-3" as "I love you," and coaxed their sweethearts to the shore to glean the hidden message.

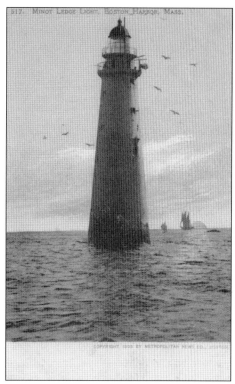

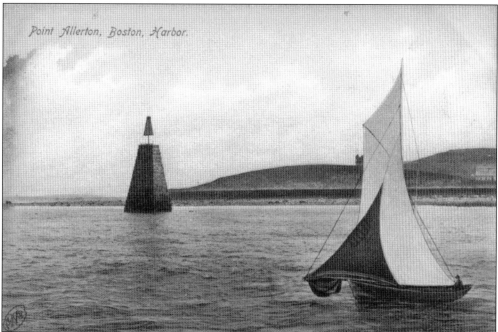

Entering the harbor, sailors and sea captains watched for a series of lights to guide them in. To find their way around the northeastern tip of Hull and into safe passage, they first steered north of the Point Allerton beacon, seen here from the northwest. The beacon now lays on the sea floor, a victim of an early-20th-century storm.

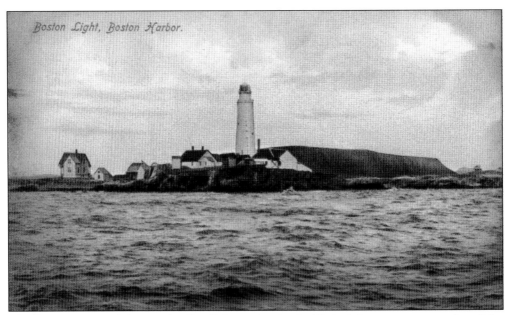

Boston Light, Boston Harbor.

The first Boston Lighthouse, the first light station in the United States, was a casualty of the American Revolution, blown up by the retreating British in June 1776. By 1783, the current tower was completed on Little Brewster Island, and now stands as the symbol of the Boston Harbor Islands National Park Area. This image shows the view of the lighthouse from the east, with Great Brewster Island in the background.

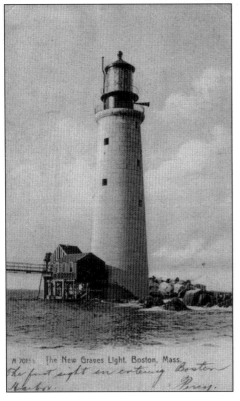

The New Graves Light, Boston, Mass.

To the northeast of Boston Light, Graves Lighthouse marks the entrance to a second, deeper, straighter channel into the inner harbor dredged in 1900. Lit on September 1, 1905, Graves Light was one of the more claustrophobic stations in the area, with no more than a walkway extending to an oil house on an outcropping of rock. That was lost during the no-name storm, or "Perfect Storm," of October 1991, but by that time the lighthouse had been automated.

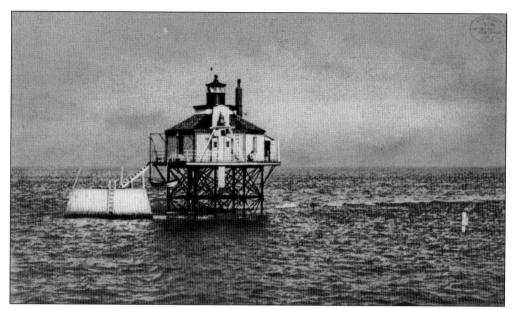

Back on the southern approach, Narrows Light stood at the western end of Great Brewster Spit, a winding sandy snake that became exposed at low tide and disappeared at high tide. Built in 1857, the lighthouse, also known as Bug Light for its spider-like construction, burned down on June 7, 1929, the victim of an errant flame from a paint-burning torch on a windy day.

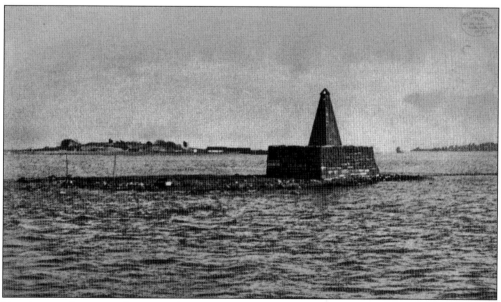

Turning northwestward to enter the Narrows, the channel for which the lighthouse was named, sailors caught sight of Nix's Mate, a daymark constructed in 1805. Although unlit, it is as valuable a tool for mariners as any lighthouse, at least during the day. Nix's Mate draws its name from a pirate legend, supposedly named for a young man wrongly hanged on the small island in place of his captain, an accused pirate, who fingered his mate as the true criminal.

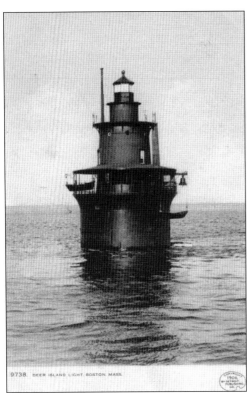

Built in 1890, Deer Island Lighthouse indicated a left turn for those folks following the rules of the road on the sea. This sparkplug style light lasted nearly 100 years, but was torn down by the Coast Guard in 1982 and replaced by a utilitarian pole with a light at its top. Any romance attached to the old light station disappeared with the construction of the pole, which itself has already been replaced by another, equally as bland structure.

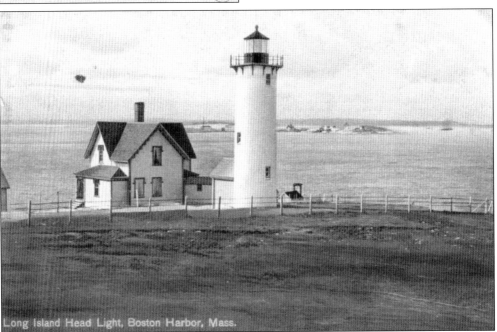

Long Island Head Light, Boston Harbor, Mass.

Sailors knew they were getting close to their destination when they could lay their eyes on Long Island Head Lighthouse. One of the harbor's oldest light stations, Long Island has held a lighthouse of some kind since 1819. In 1844, it became the home of what may have been the first cast iron lighthouse in the United States.

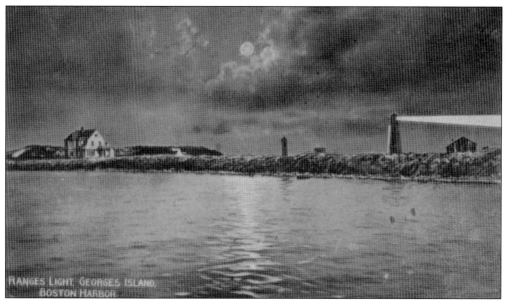

Three sets of range lights aided sailors moving around Boston Harbor. The Lovell's Island Range Lights, misidentified as being on George's Island in this image, guided ships along the southern passage of Broad Sound, the northern entrance to the harbor. Lasting only 37 years (1903–1939), they are best remembered in the writing of Harold Jennings, who grew up on the island while his father served as keeper of the lights in the 1930s.

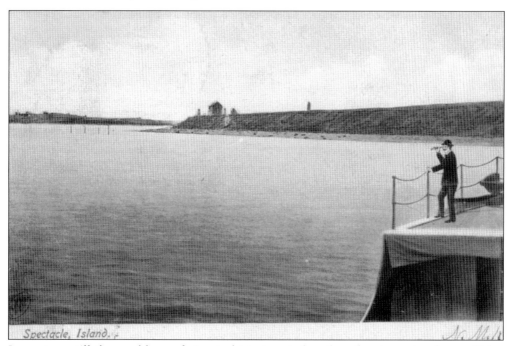

In a set-up still thoroughly confusing to historians today, the other two sets of range lights in Boston Harbor both rested on Spectacle Island. One set was known as the Spectacle Island Range Lights, the other as the Broad Sound Channel Inner Range Lights. This image shows all four towers in the distance.

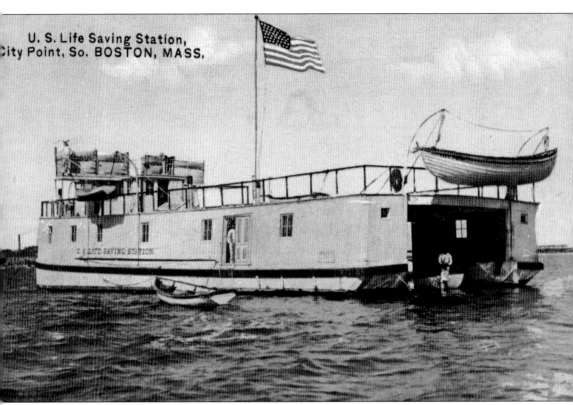

U. S. Life Saving Station,
City Point, So. BOSTON, MASS.

U.S. LIFE SAVING STATION

If all of this navigational information ever got too overwhelming for a sailor to understand, he or she should never have panicked. Boston Harbor was the birthplace of the modern search and rescue lifesaving system in America, with the formation of the Humane Society of the Commonwealth of Massachusetts in 1786, and an even earlier home for proponents of safe navigational practices, with the formation of the Boston Marine Society in 1742. By 1900, the federal government had augmented the local volunteer lifesaving network with the placement of the Point Allerton Life-Saving Station in Hull in 1890, and the floating City Point Life-Saving Station off Dorchester in 1896. Should the lights fail, or should the captain err in his dead reckoning, the surfmen of the United States Life-Saving Service would be there to answer the call.

Two

BOATS ON THE BAY

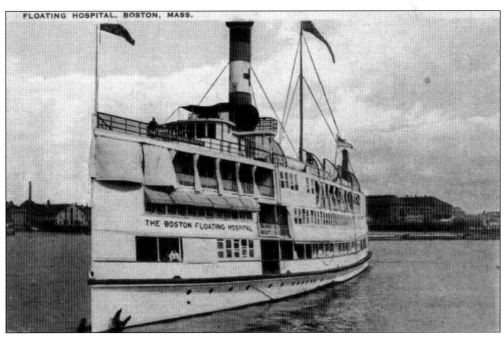

FLOATING HOSPITAL, BOSTON, MASS.

THE BOSTON FLOATING HOSPITAL

In the early 20th century, steam ruled the passenger service for local, regional, and overseas shipping. Sail, for the most part, had faded. The vessels seen on the postcards on the next several pages were familiar sights in 1900, with some even remaining in service until the 1950s. A floating hospital for children was the idea of the Reverend Rufus B. Tobey. In 1894, the Floating Hospital organization rented a small boat named *Clifford* to establish Tobey's idea for a floating hospital for children. That boat was replaced by the one depicted here, built in 1906. Besides giving care to children and their mothers, the boat was commissioned in the U.S. Navy as a hospital ship (ID2366) from January to June 1918. Returning to its owners, it served until 1927, when it burned. Thereafter the hospital's service became land bound.

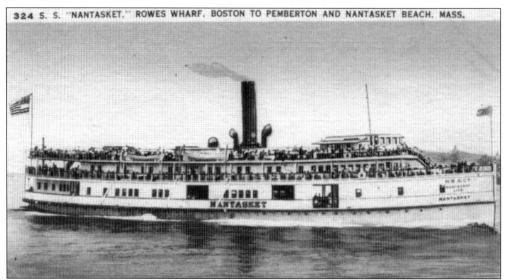

In the first three decades of the 20th century, sailing to Nantasket Beach for a day or longer on a boat such as the SS *Nantasket* was very popular. The SS *Nantasket* was operated by the Nantasket Beach Steamship Company. There were few ways to beat the summer heat before the invention of reliable air conditioning, and this was one of the ways. Boat service to Nantasket Beach continued past mid-century.

The *Mayflower* had an interesting life. On August 11, 1917, a submarine, *L-10* (SS-50), in the fog just off Spectacle Island, hit the *Mayflower*. The *L-10* was built at Fore River, and launched in 1916. The *Mayflower* had a large number of passengers aboard. They were rescued by the *Rose Standish*, another Nantasket boat that was near. The Nantasket Beach Steamship Company sued the Navy and won. The *L-10* went off to fight U-boats. The *Mayflower* was repaired and survived another tragedy, the Thanksgiving Day fire of 1929, which destroyed the Nantasket Pier and the steamships *Rose Standish*, *Betty Alden*, *Old Colony*, *Nantasket*, and the *Mary Chilton*. After many years of service on the water, the *Mayflower* was pulled up on land and became a restaurant in Hull. It was destroyed by fire in 1979.

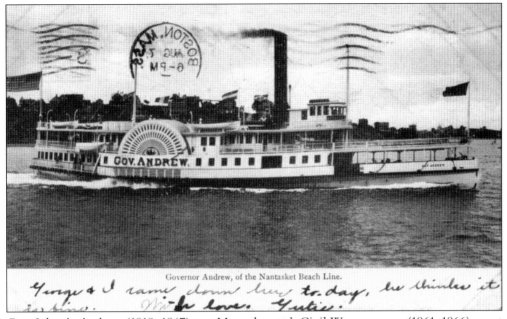

Governor Andrew, of the Nantasket Beach Line.

George & I came down here to.day, he thinks it is fine. With love. Yutie.

Gov. John A. Andrew (1818–1867) was Massachusetts's Civil War governor (1861–1866), most noted for raising 75,000 troops among which were the first to arrive in Washington to defend the capital. He also raised the Massachusetts 54th Regiment, the African American regiment made famous in the movie *Glory!*, and appointed trusted white officers to command it. In the early 20th century, the SS *Governor Andrew* was employed to service the town of Nahant, a favorite summer time haunt of Boston's upper class.

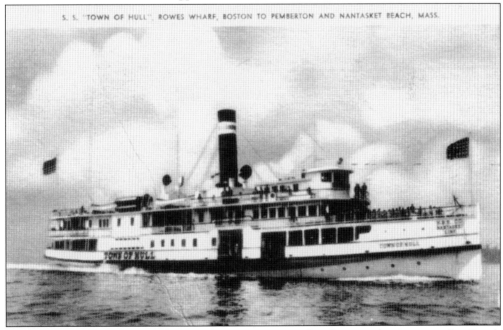

S. S. "TOWN OF HULL", ROWES WHARF, BOSTON TO PEMBERTON AND NANTASKET BEACH, MASS.

It looks like a respectable crowd on board the SS *Town of Hull* as it makes its Nantasket Beach run early in the 20th century. The name of the company can be seen on the bow. This company also made stops to other South Shore towns.

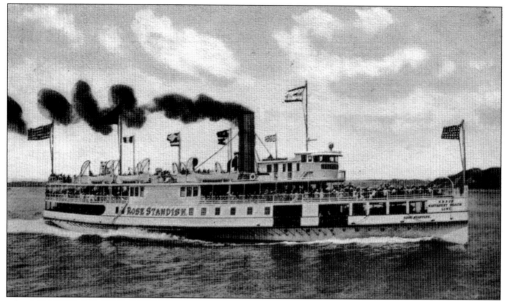

The *Rose Standish* was one of the hard-working boats of the Nantasket Beach Boat Line. The boat got its day of fame when the Cape Cod Canal was opened. On July 29, 1914, the *Rose Standish* was the first boat through the canal. It led a parade of boats including the destroyer *McDougall* (DD-54), which had then assistant secretary of the navy Franklin Delano Roosevelt aboard.

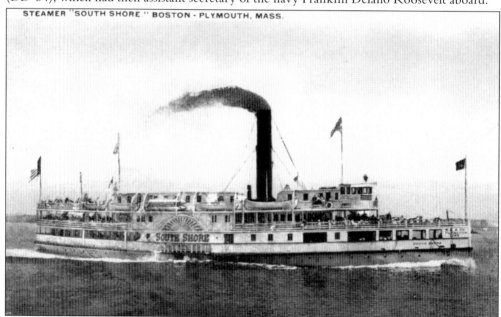

The 207-foot steamboat *South Shore* was delivered to the Nantasket Beach Boat Line by the Fore River Shipyard on June 16, 1906. On the reverse of this postcard it states: "The Plymouth Boat—The Steamer South Shore. The Historic all day sail Boston to Plymouth. View of Boston Harbor and the entire South Shore Coast Line; Relics of the Founders of our Country at Plymouth. The Mayflower sailed to Plymouth Rock in 1620. At that time the Pilgrims recognized the beauty of the scenery and settled there. Take the Steamer South Shore. Dining Salon, Staterooms, Victoria Read Ladies Orchestra."

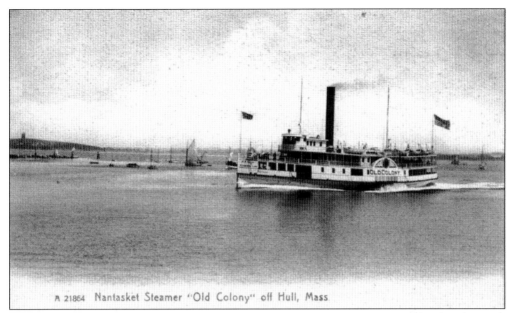

A 21864 Nantasket Steamer "Old Colony" off Hull, Mass.

The Nantasket Beach Steamboat Line boats were making summer trips to Long Wharf in Plymouth in about 1910, around the time this postcard was made of the side-wheeler SS *Old Colony*.

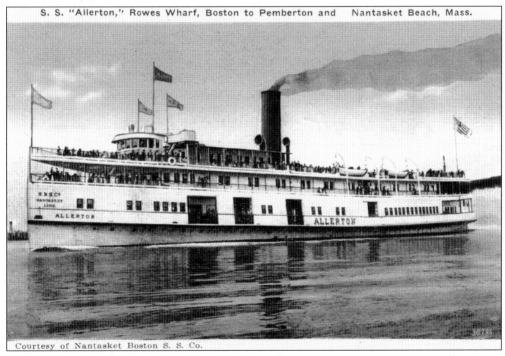

S. S. "Allerton," Rowes Wharf, Boston to Pemberton and Nantasket Beach, Mass.

Courtesy of Nantasket Boston S. S. Co.

The SS *Allerton* is a good example of the relatively small steamers, side-wheelers, or propeller-driven boats that transported thousands of metropolitan Boston people for a day at the beach over the first part of the 20th century. With few exceptions, these workhorses of the harbor did their job without any glory and with few mishaps.

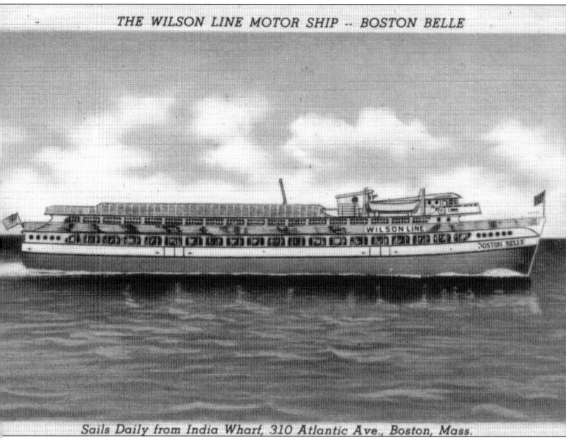

Sails Daily from India Wharf, 310 Atlantic Ave., Boston, Mass.

In the 1950s, after the Nantasket Beach Line went out of business, the Wilson Line took over the service from Boston to Nantasket and Provincetown. In the summer, boats sailed daily from Foster's Wharf, just south of Rowe's Wharf. On t.he back of a card, the *Boston Belle* was advertised as, "America's newest, ultra-modern, radar equipped, all steel luxurious 'Princess Liner', serving artistic PROVINCETOWN. Capacity 3,000 . . . immaculately clean . . . spacious SUN DECK . . . ultimate in solid comfort and relaxation. Night MOONLIGHT Dance Cruise. Except Sunday, with music by New England's finest orchestra in the World's Largest Marine Ballroom." It was a time when newer was better. Only the old *Mayflower* was still around, and it was an antique by the time the Wilson Line started its service. The Wilson Line was started as the Wilmington Steamboat Company in 1882 by Capt. Horace Wilson. The line was sold in 1929 and was renamed Wilson Line, Incorporated. The line expanded its business from Wilmington, Delaware, and Philadelphia, Pennsylvania, to the New Jersey shore, New York, and New England.

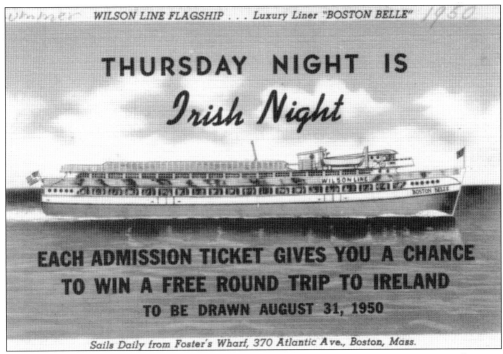

As ridership changed, boat lines needed revenue from more than regular trips. Special events and charters became a big part of the business.

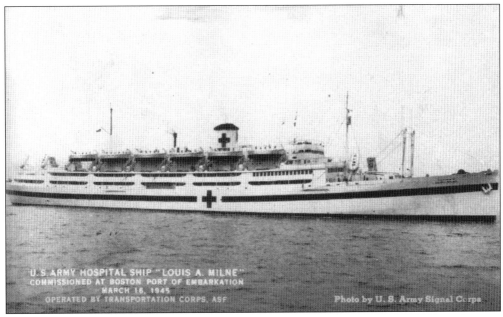

The SS *Lewis Luckenbach*, a freighter, was built in 1919 in Quincy by the Bethlehem Shipbuilding Corporation. It served 25 years, carrying freight for the Luckenbach Lines. In 1944, the U.S. Army acquired the boat and sent it back to the Bethlehem Steel plant to be converted to the USAHS *Louis A. Milne*, the largest hospital ship in the world at 10,000 tons and 527 feet long. It was scrapped in 1958.

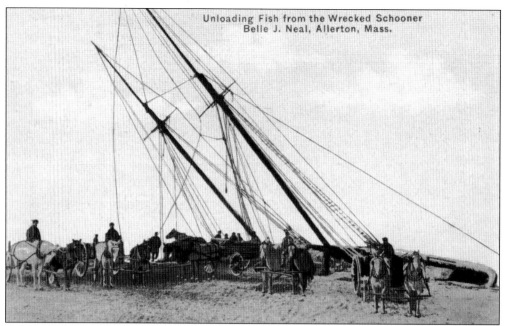

Unloading Fish from the Wrecked Schooner
Belle J. Neal, Allerton, Mass.

Sadly, not every trip in and out of Boston Harbor was a safe and successful one. The *Belle J. Neal* wrecked off Point Allerton early in 1904, spilling its cargo of oranges and turpentine into the waters of Lighthouse Channel. For weeks afterwards, wreckers could be heard falling into the water with splashes as they tried to retrieve whatever they could.

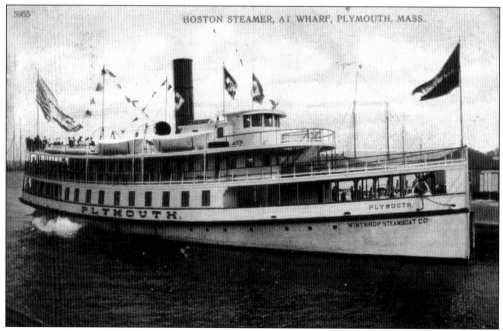

5955 BOSTON STEAMER, AT WHARF, PLYMOUTH, MASS.

The Winthrop Steamboat Company principally operated boats from Steamboat Wharf in Winthrop to Batchelder's Wharf (478 Atlantic Avenue) in Boston, weather permitting. As can be seen, their boats also served other communities such as Plymouth.

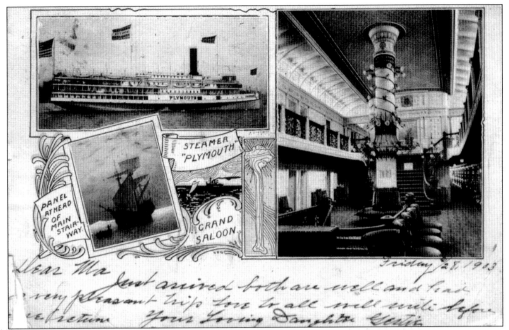

It would have been unusual for the steamship *Plymouth* to be in Boston Harbor. It was built to run from Fall River to New York. Before the Cape Cod Canal was open to steamships in 1916, going around Cape Cod to travel to New York was a lengthy trip. Travelers took the train from South Station to Fall River to board a night boat, such as the *Plymouth*, part of the Fall River Line, to New York.

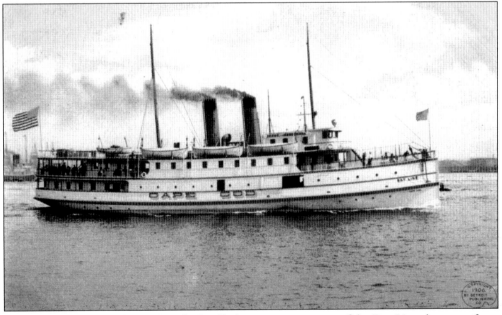

The SS *Cape Cod* and the SS *Dorothy Bradford* were two steamers of the Bay Line that went from Boston to Provincetown in the first decade of the 20th century. In 1906, a trip from Boston to Provincetown was an all day excursion. The *Cape Cod* was built in Essex by the A. D. Story shipyard in 1900.

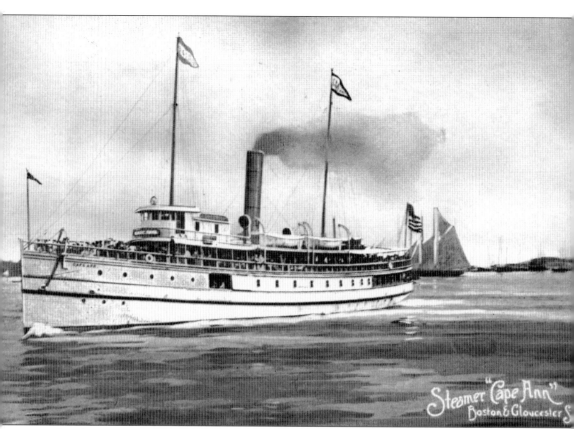

Steamer "Cape Ann"
Boston & Gloucester S

The Gloucester and Boston Steamship Company ran two boats between Boston and Gloucester, the *City of Gloucester* (1883), and the *Cape Ann* (1883), pictured here. Because of the importance of the port of Boston as a market for fish it was necessary to have reliable boat service to Gloucester, and for more than 40 years such a service existed.

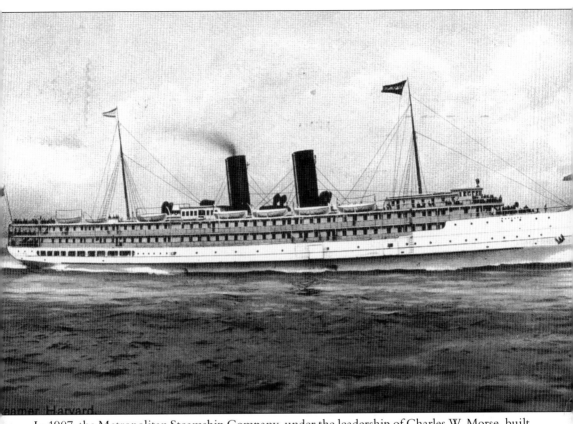

In 1907, the Metropolitan Steamship Company, under the leadership of Charles W. Morse, built two fast ships to sail from Boston to New York, the *Harvard* and the *Yale*. This was in direct competition with the Fall River Line. The ships were elegant, popular, and they made money. In 1907, there was a national financial panic; some believed Morse was one of those responsible for the scare. In 1910, he was sentenced to 15 years in jail for fraud, faked a deadly illness, and was pardoned to live a long life. In 1908, *Harvard* and *Yale* headed to the West Coast to work for the Admiral Line of Tacoma, Washington. In 1918, the U.S. Navy bought the ships as troop transports. The *Harvard* was renamed USS *Charles* (ID1298) and used as a troop ship. In 1920, it was sold to the Los Angeles Steamship Company (1920-1937). The *Harvard* was wrecked in 1931, off Point Arguello, California.

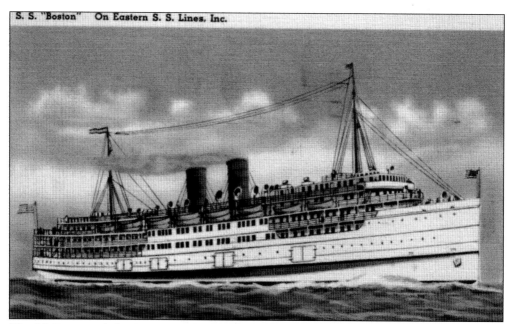

S. S. "Boston" On Eastern S. S. Lines, Inc.

The SS *Boston* and the SS *New York* were ships that transported people between Boston and New York via the Cape Cod Canal. The ships were part of the Eastern Steamship Company, established in 1901. The company operated boats to points in Maine as well as Yarmouth, Nova Scotia. The Depression, World War II, and the invention of the automobile and the airplane all contributed to the end of this type of boat service.

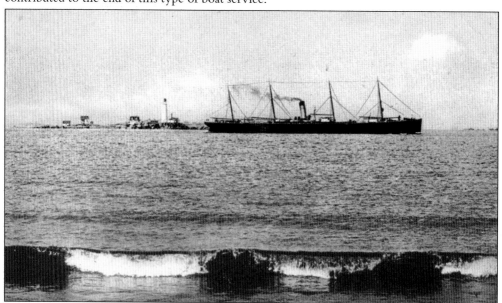

This steamer, passing Boston Light, is most likely the *Columbian*, a Leyland Line ship built in 1890. It carried livestock from Boston to Liverpool and other English ports. This postcard photograph was made in 1905, the same year Graves Light was constructed and lit, and when the new main channels to its north were open to shipping. The *Columbian* was lost to fire in 1914. Inward bound or outward bound, the vessels plying the waters of Boston Harbor certainly made for beautiful sights.

Three

ISLANDS
LARGE AND SMALL

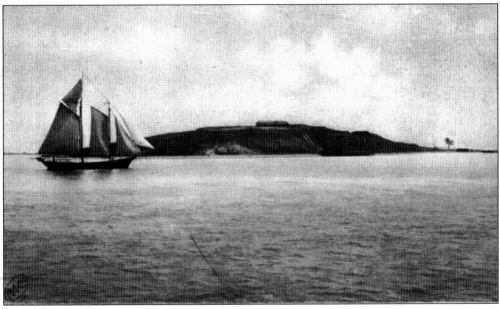

Boston Harbor was heavily fortified when the first postcard was mailed from the region at the beginning of the 20th century. Coastal artillery sites rimmed the harbor with overlapping fields of fire designed to attack an intruding enemy navy's vessels from several points at once. Many of the islands and headlands bordering the approach to the city of Boston, therefore, have had some military presence at one time or another during the first four centuries or so of settlement in Massachusetts Bay. One of the earliest sites, Fort Winthrop on Governors Island, was operational as early as 1808 (then called Fort Warren), but had been damaged by a mine explosion in 1901. It was leveled in 1946 to make way for Boston's Logan International Airport.

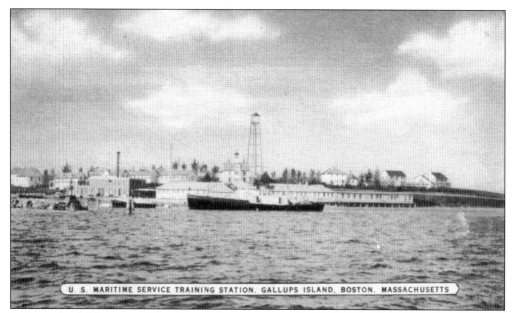

U. S. MARITIME SERVICE TRAINING STATION, GALLUPS ISLAND, BOSTON, MASSACHUSETTS

Gallops Island, like many of the islands of Boston Harbor, has lived many lives, from campground for Civil War soldiers, to quarantine station, to summer resort, to training station for the U.S. Maritime Service, the training division of the War Shipping Administration during World War II. The island has been closed to the public in recent years due to asbestos being found in the debris of the old buildings.

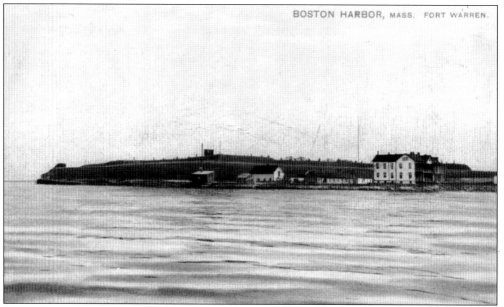

BOSTON HARBOR, MASS. FORT WARREN.

Fort Warren on George's Island is the most widely-known of the historic sites in Boston Harbor. The granite fort on the island took more than two decades to be completed, started in 1833, and not truly finished until 1869, already outdated by the time the first Confederate prisoners of war arrived during the Civil War. Historian Edward Rowe Snow promoted the legend that a "Lady in Black" haunts the island in desperation over the loss of her husband, a Confederate prisoner kept on the island.

Long Island's first military inhabitants served there during the Civil War, when Camp Wightman opened as a training facility in 1861. Fort Strong opened in 1870 under the name Long Island Military Reservation, and remained an important defense site through the 1960s. The new name was adopted in 1899.

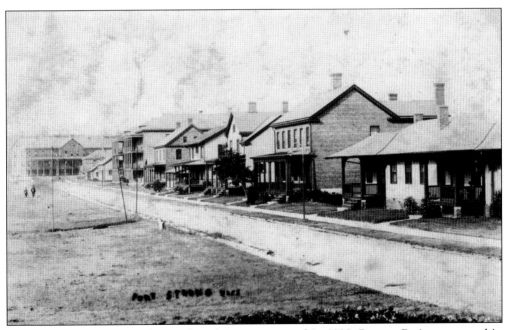

Three batteries—Hitchcock, Ward, and Drum—opened in 1899, Battery Basinger opened in 1901, and three others—Smyth, Stevens, and Taylor—became operational in 1906. In that latter year, a mine casemate for the control of mines on the northern approach, via President Road, dredged in 1905, was built on Long Island. During the 1950s, showing the transformation of the American coastal defense system over time, Fort Strong was converted to a Nike missile launch site.

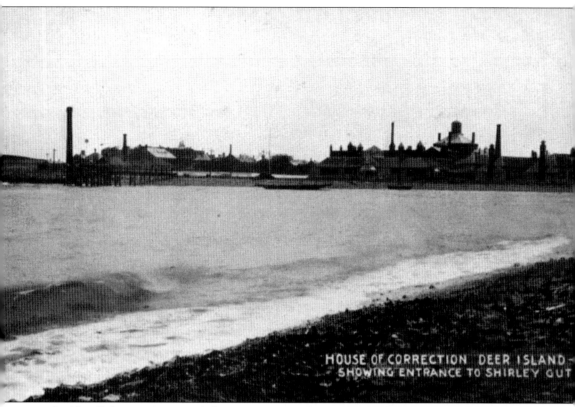

HOUSE OF CORRECTION DEER ISLAND SHOWING ENTRANCE TO SHIRLEY GUT

Amidst all the merriment and cheeriness portrayed on many of the postcards of Boston Harbor, there still could be found lurking members of society who had in some manner wronged their fellow men and women. Deer Island had been used in the past as a detention center for Native Americans (during King Philip's War) before becoming the site of a house of corrections for the city of Boston. This particular image shows the new, 1904 version of the Deer Island House of Corrections, which eventually was demolished to make way for the modern sewage treatment facility on the island in 1991. The Suffolk County House of Corrections opened at South Bay in Boston on December 26 of that year. The island was also home to Fort Dawes (originally the Deer Island Military Reservation), part of the harbor's coastal defense network, from 1989 to 1943.

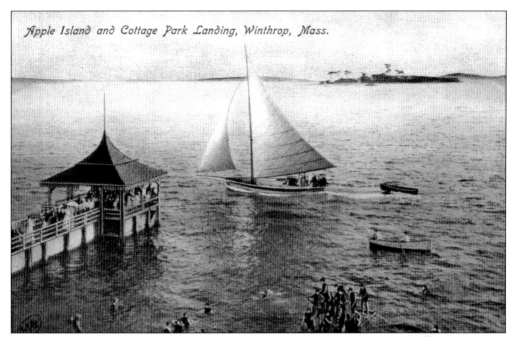

Apple Island and Cottage Park Landing, Winthrop, Mass.

Apple Island bore several names during the 19th century, including Belle Isle, Susanna, and Breed's Island, yet today, memories of its offshore silhouette have all but faded from memory. In the 1940s, Apple, Bird, and Governor's Island fell victim to development, all becoming part of Logan International Airport.

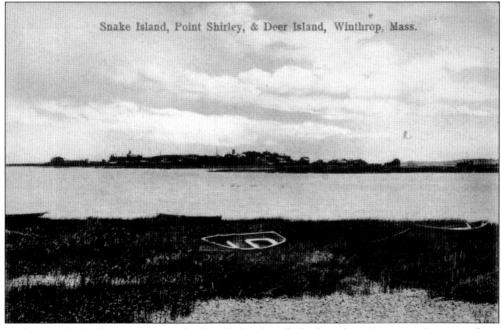

Snake Island, Point Shirley, & Deer Island, Winthrop, Mass.

Snake Island, also known as Bare Island to the locals as far back as the 1680s, gained its name from its shape. Housing has been at a premium on the island; one pair of brothers used a grounded steamer as their home, while other squatters lived in small cabins. For the most part, the island's three acres have been used for recreational purposes by the people of Winthrop.

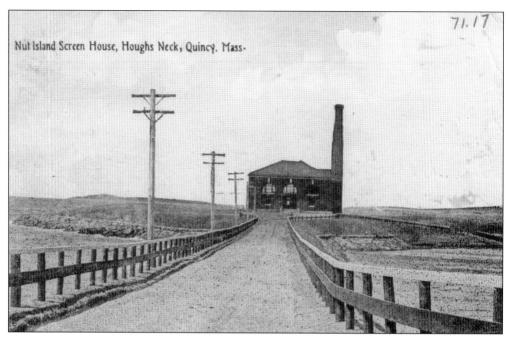

Nut Island Screen House, Houghs Neck, Quincy, Mass.

Nut Island is no longer an island, now connected to the Quincy mainland by means of a causeway. Since the 1890s, it has been used as a wastewater treatment facility, but was once also home to a heavy ordnance foundry and testing facility. Fifteen-inch guns once boomed out from the island, searching for targets on Peddocks Island to the northeast.

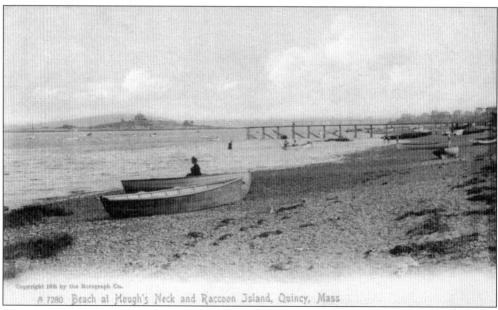

Copyright 1905 by the Rotograph Co.

A 7280 Beach at Hough's Neck and Raccoon Island, Quincy, Mass

The three-and-a-half acres of Raccoon Island, off the eastern shore of Quincy's Hough's Neck, have little recorded history other than use as grazing land and as a religious summer camp in the 1930s. Still, at the beginning of the 20th century, any local scenery was subject to the postcard publisher's whims. If one could see it from shore, it most likely ended up on a postcard.

This little island in Hull Bay went from being called Hog, to Park, to Hog, to Spinnaker, over the course of a century. Once grazing land (Hog), it became a failed summer colony (Park), the site of the Fort Duvall coast artillery site (Hog), an off-site school facility for the Hull school system, and finally a condominium development (Spinnaker).

Just 500 yards off the Weymouth mainland, Grape Island's main claim to fame is a skirmish fought during the American Revolution over hay. A local Tory offered hay to British troops, and when they came to collect it on May 21, 1775, South Shore patriots disrupted their foraging.

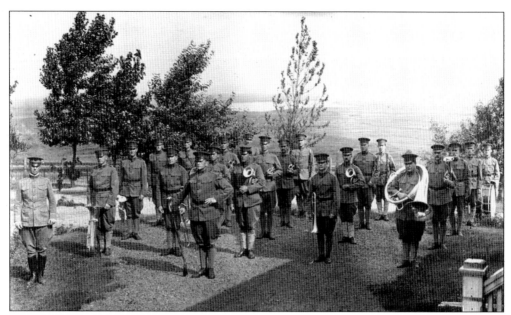

Although not on an island, Winthrop's Fort Banks, or, originally, the Winthrop Military Reservation, played its part in the region's defense. Located just a mile from the center of Winthrop, the fort, like many military sites built near municipalities of the day, played a prominent role in the community, encouraging interaction between the townsfolk and the soldiers at on-site movies, dances, and more.

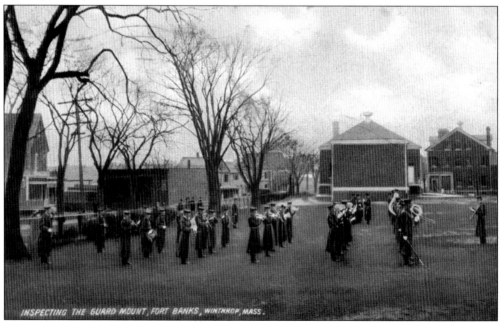

INSPECTING THE GUARD MOUNT, FORT BANKS, WINTHROP, MASS.

The last major firing of guns at Fort Banks took place in 1904, yet the site remained in the hands of the federal government until it was declared Army surplus in 1950. A little more than a year later, with the opening of the Korean War, the fort reopened as part of the Nike missile defense system in the harbor. Today, the site of Fort Banks has been refitted for condominiums, senior housing, and more.

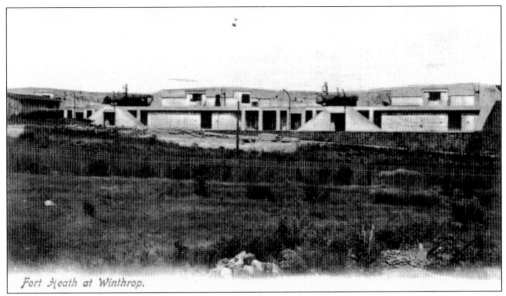

Fort Heath at Winthrop.

Less than a mile from Fort Banks, Fort Heath was known as the Grover's Cliff Military Reservation from 1895 through 1899. The site eventually was used for a Coast Guard radio-direction finding station in 1933, and as a test site for navy fire-control systems. Today an apartment complex covers the land, obscuring the history presented in this postcard.

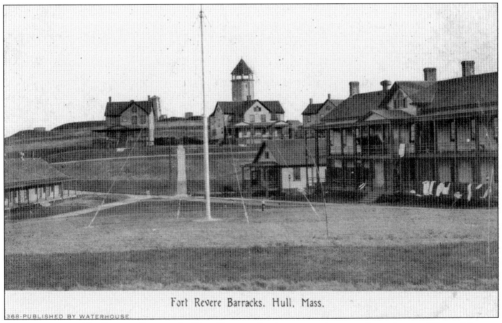

Fort Revere Barracks. Hull, Mass.

368-PUBLISHED BY WATERHOUSE

Across Boston Harbor to the south, Fort Revere had connections to American military history long before this postcard was taken, as the site of an early earthwork fort used during the American Revolution. The tower atop the hill was the first all-reinforced concrete standpipe of its kind in the country. The building directly below the tower is today the Fort Revere Officers Quarters Museum, home of the Fort Revere Park and Preservation Society.

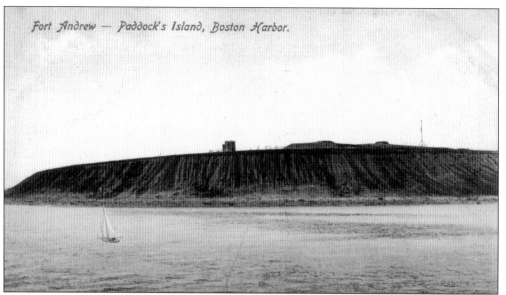

Fort Andrews (not Andrew, as seen on this card) on Peddocks Island, an elongated stretch of land reaching from Nut Island off Quincy to Pemberton Point in Hull, is famous locally as a prisoner of war camp for Italian soldiers during World War II. The people of Italian heritage from surrounding towns went out of their way to care for the military men of their homeland, and some young Italian American women even met their future husbands on the island.

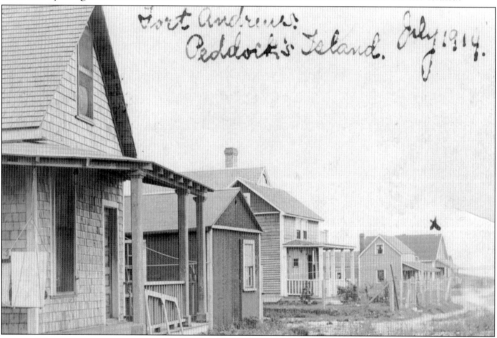

Named for Maj. Gen. George Leonard Andrews of Bridgewater, Fort Andrews was home to five gun batteries. Although the site had seen a military presence during the American Revolution, it was the Spanish-American War that led to the thorough fortification of the island. Twenty-six Fort Andrews structures remain tenuously standing today. Cottages for the families of the soldiers shared the islands with a predominantly Portuguese fishing community.

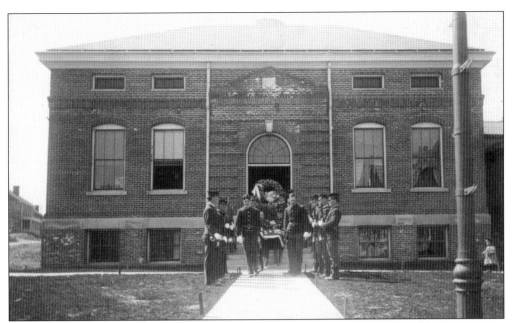

Occasionally, postcard images, especially real-photo cards, capture specific moments in time that have otherwise been lost to history. In this image, a casket is carried out of the gymnasium at the far end of the training fields of Fort Andrews on Peddocks.

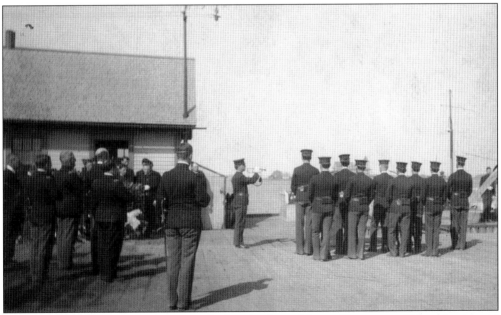

It is obvious from the series of postcards that the funeral is a military one. Although postcard dealers worked mostly in mirth and sentimentality, cards like the two on this page remind us that military life was not always pomp and circumstance, shined shoes, and precision drilling. Somewhat oddly, death found a way to creep into the postcards of Boston Harbor.

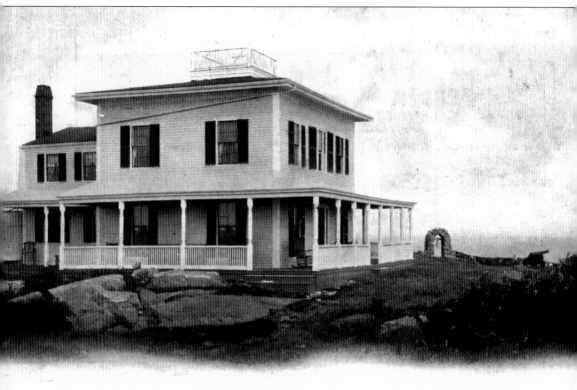

Summer Residence of Melvin O. Adams at Republic of Middle Brewster in the Atlantic Ocean

"No man is an island," said English poet John Donne, yet any man that has the means can live on one. Ashburnham's Melvin Ohio Adams found that he could best unwind at his private estate on Middle Brewster Island, at the outer reaches of Boston Harbor. Adams, a successful lawyer who worked on the legal defense of Fall River's Lizzie Borden (accused of hacking her parents to death with an axe in 1892), achieved the position of president of the Boston, Revere Beach and Lynn Railroad. His estate on the island, though, was just one of several belonging to prominent Massachusetts men and women who used the island for their personal retreat. Today stone walls and chimneys stand as silent reminders of those bygone days. Thankfully, though, access to the harbor is again at a historical peak, as the National Park Service has designated the Boston Harbor Islands a National Park Area, meaning that while hidden, the islands' military, social, and cultural history can still be explored.

Four

A Sailor's Paradise

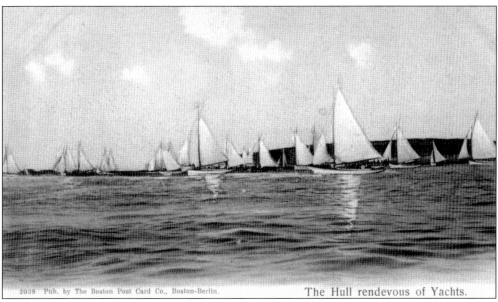

2038 Pub. by The Boston Post Card Co., Boston-Berlin. The Hull rendevous of Yachts.

Ah, the sights and sounds of summer by the seashore. Boston Harbor, it would seem to today's visitor, has always been blessed with the regal beauty of offshore yacht races. A sea of billowed white sails enhanced occasionally by spinnakers of many colors moving silently across the distant waters make for a pleasant sight. But yachting is a relatively new phenomenon, when one looks at the grand scale of history. The first Massachusetts yacht club, the Boston Yacht Club in Marblehead, was incorporated in 1866, although informal races were known to have been running since the *Sylph* ran from Boston to Nahant against the *Dream* on July 8, 1835. By the beginning of the 20th century and the heyday of the postcard, yachting was firmly established as a major pastime in Boston Harbor, and one could travel from bay to cove by following the yacht clubs along the shore.

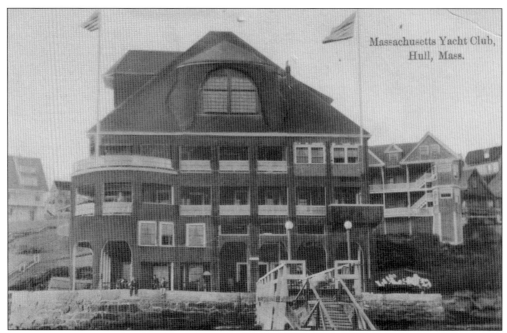

The original 1882 Hull Yacht Club building, now mostly gone (only the attached dormitory building on the right remains), boasted three bowling alleys, a billiards room, and a dining room. The club, formed two years previously, also admitted the first African American yachtsman to membership in the country, George G. Garraway. The club merged with the Boston Yacht Club in 1903 (after already having merged with the Massachusetts, formerly Dorchester, Yacht Club in 1899), with its four-story clubhouse becoming the local station of that organization at the southern edge of the harbor.

A second Hull Yacht Club formed in 1932, just a few years after the old clubhouse building was torn down. This club, still active today, makes use of the Old Beacon Club that once stood on Allerton Hill overlooking Boston Light (hence the name). The building was moved in two pieces to its current location on Fitzpatrick Way in 1939 after a major dredging and filling project created Mariners' Park, home to both the yacht club and the Nantasket Beach Saltwater Club. The turnbuckles holding the two halves of the building together can still be seen in the rafters.

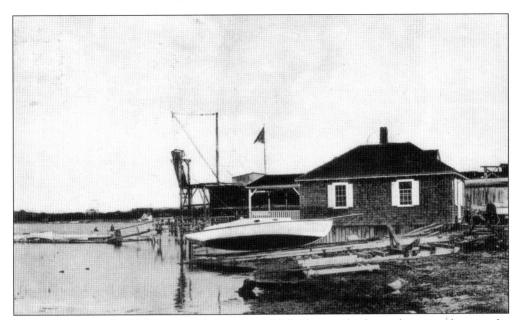

The Hingham Yacht Club competed for space with bathers and others who wanted to use the protected cove for work and play, including lumber companies. Set at the foot of North Street, the club formed in 1895, the brainchild of six young Harvard men. Fifteen years later, according to *Not All is Changed: A Life History of Hingham*, the club consisted of 125 members with many more names on a waiting list.

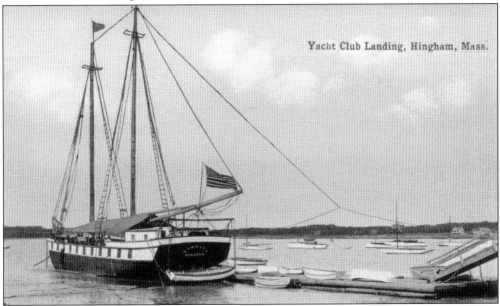

Yacht Club Landing, Hingham, Mass.

Rather than expand their building, the club instead purchased the schooner *Otranto* as an annex, intending to sail it to Marblehead annually for Race Week. But it proved to be more of a headache than it was worth, and the club began to look elsewhere. By 1928, they were being squeezed out by their fun-seeking competitors anyway, not to mention the growing use of today's Route 3A (then Route 3) as a major highway to Nantasket Beach. The members purchased the old Crow Point steamboat landing and began building their new home.

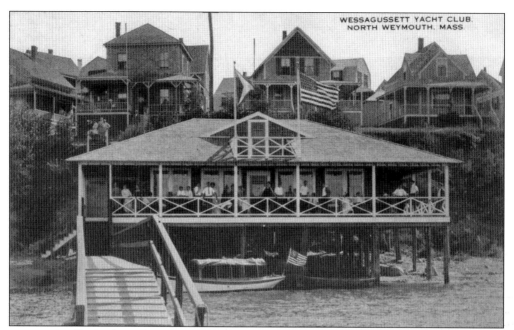

Sometimes all one has is an idea. The founders of the Wessagussett Yacht Club in Weymouth knew what they wanted to do, and that they wanted to do it together. The postcard era was also the era of grand social interaction in America, when the combination of standardized work weeks, affordable transportation, and improved communication meant that people of common interests could gather in ways they never could before.

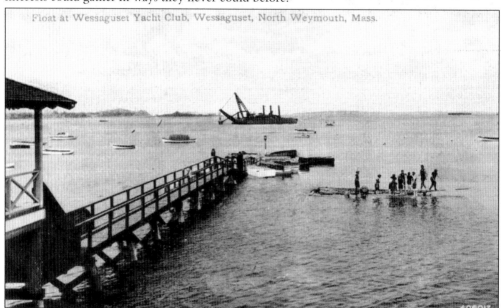

The gang at Wessagussett had almost everything they needed, as some had boats, and they could get those boats onto the water. But when they formed in 1902, they were missing one thing: a clubhouse. It was not until 1910 that the Wessagussett Yacht Club built their permanent home. Still active today, the Wessagussett Yacht Club strives to "promote yachting and to encourage the study of nautical science."

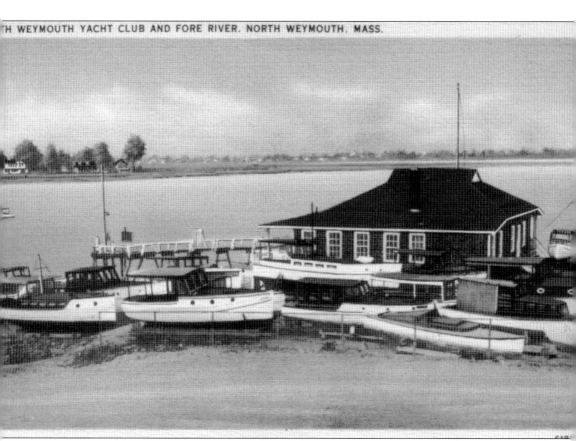

Like many communities, Weymouth had more than one yacht club. The North Weymouth Yacht Club formed in 1914, near the mouth of the Fore River, and although it lasted at least into the 1930s (this postcard dates from that time period), the club no longer remains in operation today. The image here shows, too, that the club had made a conscious decision to allow power boaters into its midst, perhaps as a way of boosting membership while competing with so many similar organizations along the shore. The yacht club sat at the corner of Birchbow and Fore River Avenues.

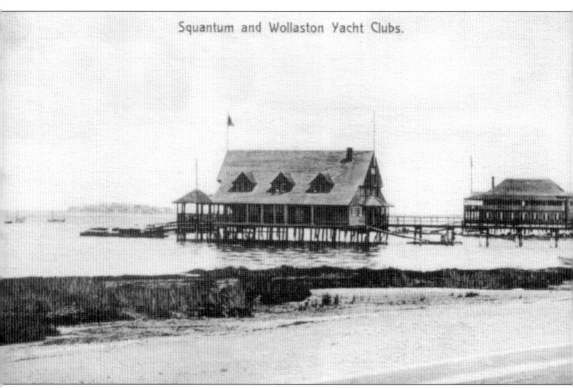

The two-and-three-tenths mile stretch of Wollaston Beach in Quincy would one day be set aside as park land by the state of Massachusetts, but that had not happened by the time this postcard image was taken in the early 20th century. The Squantum Yacht Club, shown here in the foreground, was never in Squantum, a specific geographical location to the north, but instead well to the south along Quincy Shore Drive. Squantum sailors, though, have made good use of the club since its inception in 1890 (and the current name was adopted two years later). Today, the Squantum Yacht Club is home to the Lipton Cup Regatta, a name harkening back to the early days of the America's Cup, when Ireland's Sir Thomas Lipton, of tea fame, challenged American sailors to a series of five races, and lost every single one of them.

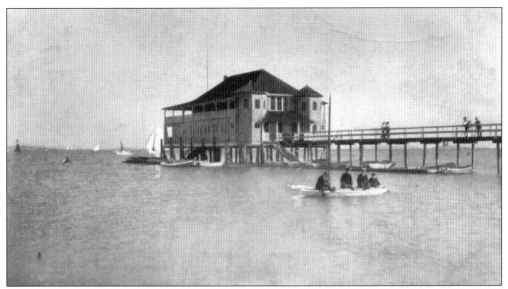

In the background of the image on the previous page, and to the south of the Squantum Yacht Club, sits the Wollaston Yacht Club, just a stone's skip across the water from its neighbor. During a period of rapid growth for Quincy, when it jumped from about 7,000 to 10,000 residents in a 10-year period from 1870 to 1880, the Wollaston section of town absorbed much of the incoming population.

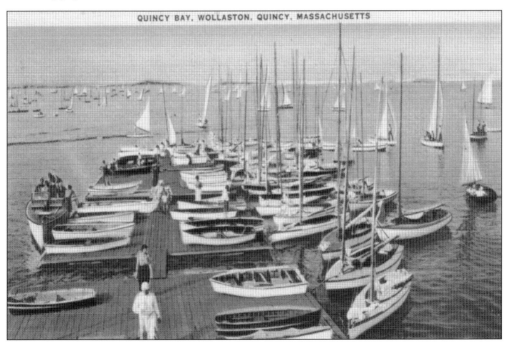

QUINCY BAY, WOLLASTON, QUINCY, MASSACHUSETTS

The area would continue to grow and prosper. One local resident, Howard Deering Johnson, borrowed $2,000 in 1925 to open a corner store in Wollaston, but soon switched his focus to developing a new and better tasting ice cream, eventually building the chain of stores that bears his name, Howard Johnson's. Johnson himself was known to be out on the water, although he preferred power to sail.

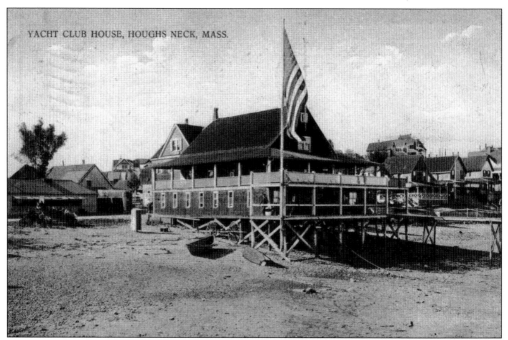

YACHT CLUB HOUSE, HOUGHS NECK, MASS.

The Quincy Yacht Club rests on the southern slope of Great Hill on Hough's Neck, facing eastward into Quincy Bay. Warren S. Parker, Quincy historian and longtime building inspector for the city, noted in lectures given in the 1920s that his records indicated yacht races off Hough's Neck as early as September 2, 1856.

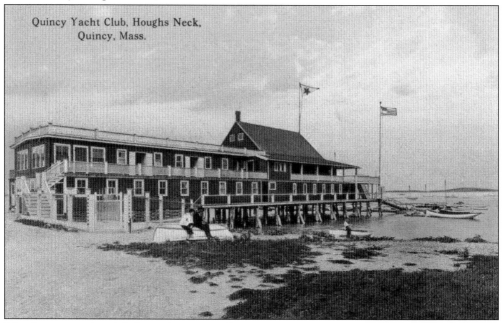

Quincy Yacht Club, Houghs Neck, Quincy, Mass.

The Quincy Yacht Club formed in 1874, when the hottest local attraction was clam chowder at the Dew Drop Inn. By 1888, they had built their clubhouse, but, seeking that waterfront feel, they moved it in 1912 down to the water's edge. There it was expanded with additional piazzas and an ell that provided space for a dining room and other amenities.

The Savin Hill Beach Association formed in the early summer of 1875, purchasing an old wooden schoolhouse for use as its headquarters, and moving it to the beach. Racing became just one focus of the club, but local rivalries with Harrison Square yachtsmen, who would form the Dorchester Yacht Club, led to the name change and incorporation of the Savin Hill Yacht Club on October 10, 1888. The new clubhouse was opened on July 15, 1890.

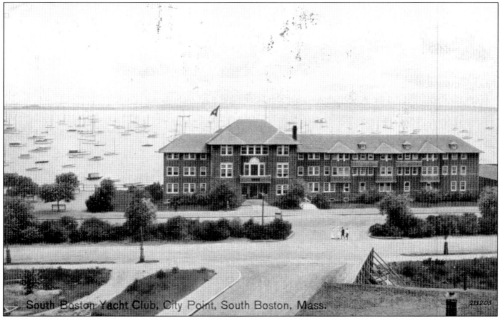

South Boston Yacht Club, City Point, South Boston, Mass.

The South Boston Yacht Club got an even earlier start, forming just after the end of the Civil War, in 1868. The first yacht club building was constructed at the foot of K Street, but was moved to the corner of Sixth Street and Farragut Road on February 7, 1870. In 1886, the building was expanded to accommodate the growing ranks of the club, but was demolished in 1899 to make way for the construction of the Strandway. A new building—partially funded by the City of Boston—was dedicated on May 30, 1899.

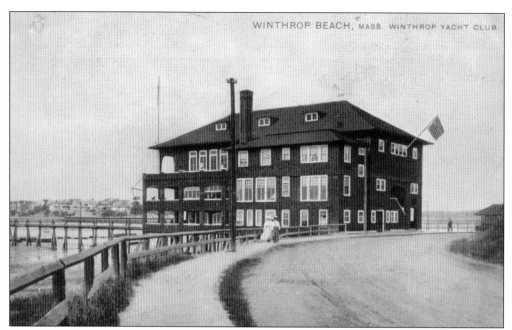

Like most others yacht clubs in Massachusetts Bay, the Winthrop Yacht Club started small, with a membership of just eight men in 1884. Membership grew to the point that a new clubhouse, shown here, was erected quickly after the old one burned down in 1904. The club today boasts some 700 members on its rolls.

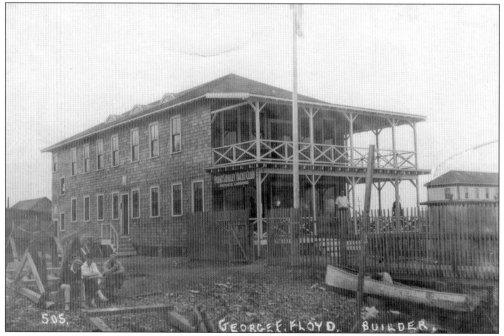

Winthrop, with only one-and-six-tenths square miles of land partially spread out along a thin sandy peninsula reaching south-southeast into Boston Harbor, at one time had three yacht clubs, such was its prominent and favorable positioning on the waters of the bay. The Point Shirley Yacht Club is shown here after a major renovation that added the second floor piazza.

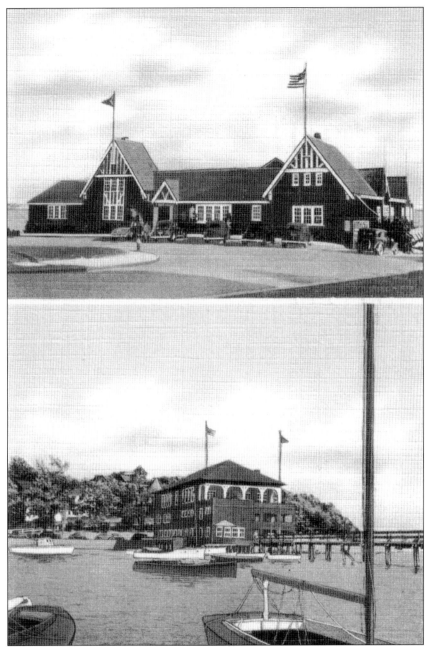

The third yacht club in Winthrop came as a result of a disruption in ferry service from the city of Boston. When, in 1902, the Boston Steam Ship Service announced that it would no longer be running to Winthrop, local businessmen ruminated on the idea of purchasing and converting the company's dock to become the physical foundation of a new yacht club. Six years later, a new clubhouse opened with the typical amenities of the day for a club at which only men were allowed as members, including bowling alleys and a billiards room. Eighteen years later, on July 8, 1926, the club burned down. Nonplussed, the members still held their Waterfront Carnival three weeks later on a local estate at Sunnyside. The new clubhouse, still in use today, opened in 1928.

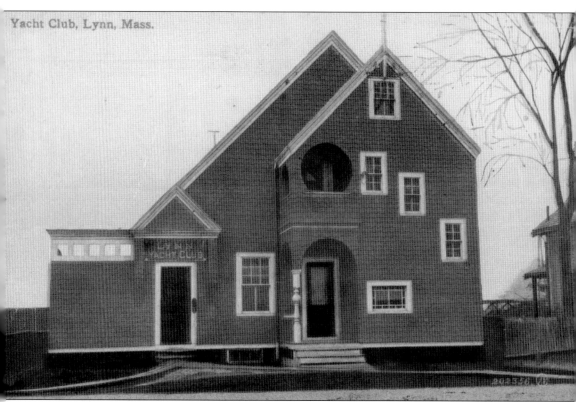

Yacht Club, Lynn, Mass.

Lynn, Massachusetts, was a thriving shoe-making community when the Lynn Yacht Club opened in 1870. Neither the Civil War nor a major fire in 1869 that destroyed the heart of the city's manufacturing infrastructure could stop the community's growth. The Lynn club formed on March 7, just two days after the Eastern Yacht Club formed in Marblehead, making it the second oldest club of its type on the North Shore of Boston. The Lynn sailors, though, beat their Marblehead friends to the starting line by nearly a month, running their first race on June 17 of that year. Today Boston Harbor, from Hull to Lynn, fills with those same sights of summer seen a century and a half ago. While the majesty of steamboats have come and gone and newer and better marine engines are being developed every day, the yachtsmen of Boston Harbor simply sail on, partaking of one of America's proudest traditions.

Five

Hull and
Nantasket Beach

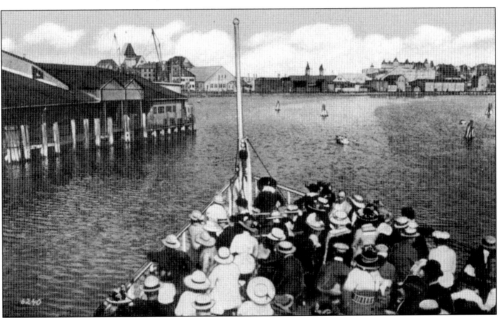

With industrialization came urbanization. Industrialization brought smoke stacks, factory whistles, and rush hours. Urbanization brought people into closer confines with each other than they ever had been in American society. There should be no wonder, then, why the people of Boston wanted to escape the sights, sounds, and smells of the city when the whistle blew at the end of the week, and to head for places like Nantasket Beach. A short steamboat's ride away lay three-and-a-half miles of sand, roller coasters, shore dinners, and sunsets. As the boats approached the Nantasket Steamboat Wharf, their riders anxiously anticipated capitalizing on their brief getaways from the harshness of American city life in the first decades of the 20th century.

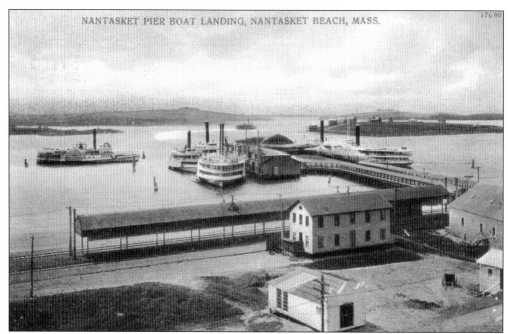

The steamboat fleet moved between Rowe's Wharf in Boston and two stops in Hull, the Pemberton Steamboat Wharf at the western tip of the community and the Nantasket Steamboat Wharf on the estuary of the Weir River. Gliding around Hampton Hill on the boats, steamboat goers watched the formative years of World's End Reservation, shown here in the distance, laid out by Frederick Law Olmstead in 1893.

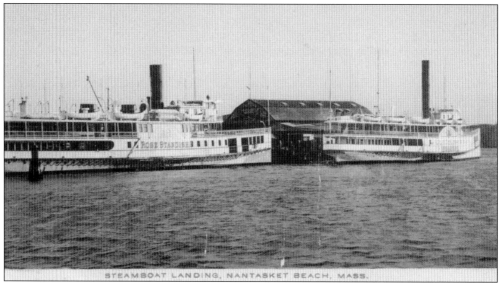

The classic side-wheel steamers, named mostly for local politicians and other people of note, offered all of the amenities of the day, all the way down to professionally painted murals in the open areas of the boats. But alas, the heyday of Hull's steamers ended earlier than expected, when a Thanksgiving Day fire in 1929 destroyed five of the six boats laid up for that winter season. One boat, the *Mayflower*, reopened as a night club after being run aground, before it too burned on November 10, 1979.

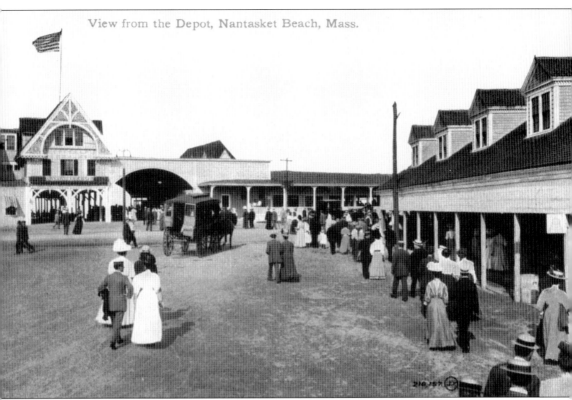

Stepping ashore at Hull, crossing the railroad tracks that ran from Hingham, one had to watch out for pickpockets while perusing "Peanut Row," shown here on the right, where goods of all kinds could be purchased. Straight ahead the first of the great Hull hotels to be seen came into view, the Hotel Nantasket. A 1,000-foot boardwalk had been washed away from the hotel during the Portland Gale of 1898, but the building survived that storm and remained an attraction for years to come. A piece of the hotel, a pavilion used mainly for band concerts in summer, existed into the early 21st century, but eventually gave way to new construction during the summer of 2003.

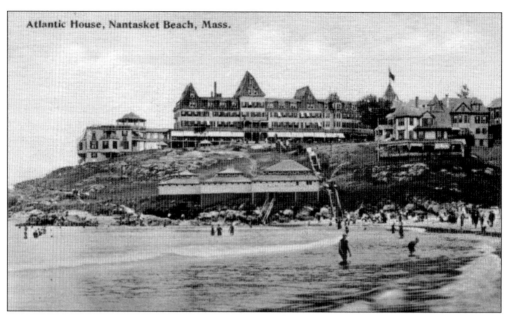

Atlantic House, Nantasket Beach, Mass.

The Atlantic House, high atop the eastern edge of Atlantic Hill, beckoned visitors, such as Pres. William McKinley, to enjoy the delights of a Hull summer. Built in 1879, it burned to the ground in the winter of 1927, supposedly the work of an arsonist. Opera star Enrico Caruso once performed here, and one-time presidential candidate William Jennings Bryant spoke in its ballroom as well.

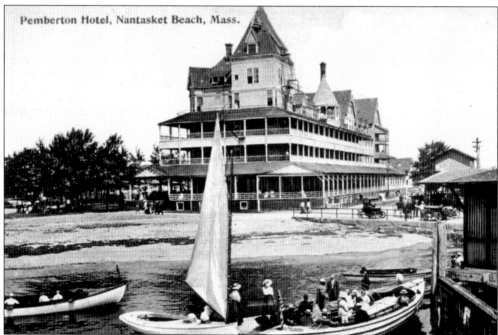

Pemberton Hotel, Nantasket Beach, Mass.

At the northern end of town, the Pemberton Hotel delighted in their motto, "The Coolest Place on the Coast." With a steamboat wharf nearby, train lines that ran directly to the hotel's front door, and unparalleled views of both the inner bay and outer harbor, the Pemberton Hotel attracted folks looking for less honky-tonk and more genuine relaxation.

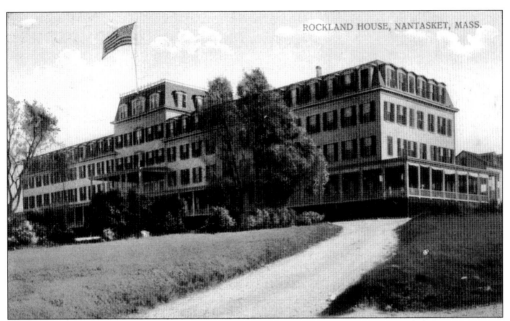

The Rockland House once ranked as the largest hotel in the United States, with 360 rooms. It had started out in 1854 as a 30-room getaway spot, but the post–Civil War industrial boom that amplified the differences in American class structure created a demand for shore side escape sites for those folks who could afford to get away. Pres. Grover Cleveland stayed here when he visited Hull.

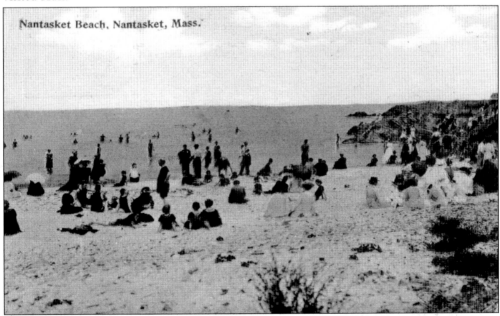

Nantasket Beach, Nantasket, Mass.

And, of course, the beach itself held its own special charm for city dwellers escaping the heat. While late-Victorian values and fashions still ruled the day in the early 20th century (men were still being arrested for topless bathing in Hull in the late 1930s), a dip in the ocean in the heavy, rented woolen bathing suits of the day still beat the stifling heat columns rising from the street to a porch on a three-decker in South Boston.

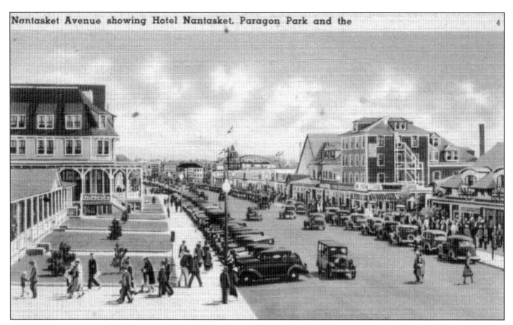

Nantasket Avenue, laid out in 1870 long after the Rockland House had been established, grew as the American appetite for relaxation at the seashore expanded. Eventually traffic became so heavy on the roadway that the town opened a second access road to the beach, George Washington Boulevard, in 1932, naming it for the father of our country on the bicentennial of his birth.

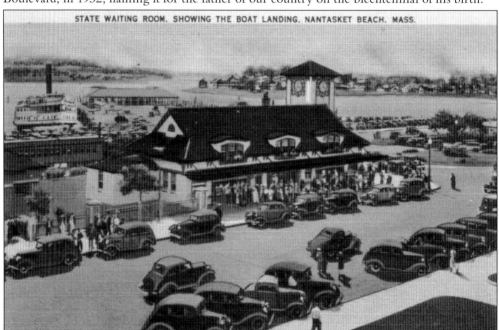

If one had walked from the steamboat wharf and across Nantasket Avenue to the Hotel Nantasket, and then turned the other direction, one would have seen the waiting room for the trolleys and trains that moved up and down the beach from 1880 to 1937. The first overhead third rail electrified line tested in the United States was experimented on at Nantasket. Today the "state waiting room" is used as the headquarters for the Paragon Park Carousel.

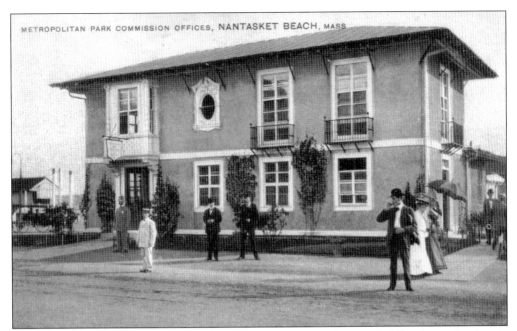

The Metropolitan Park Commission took over Nantasket Beach in 1899, following a near decade of decadence in local politics that allowed corruption and graft to rule the first, "golden" mile of Nantasket Beach. The old police station still stands at the corner of Nantasket Avenue and Wharf Avenue, next to the carousel, awaiting reuse.

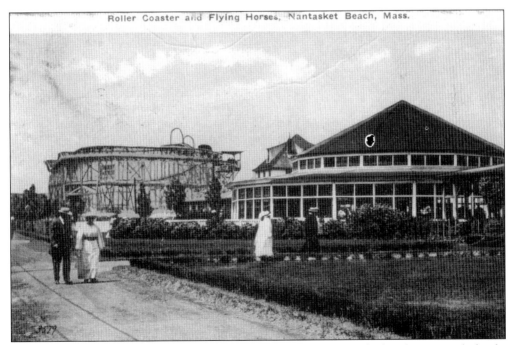

Across the street and just a little farther north, early amusements on the beach prospered, thanks to the drawing power of the flying horses (not the Paragon Carousel, which was built in 1928) and Grant's Roller Coaster.

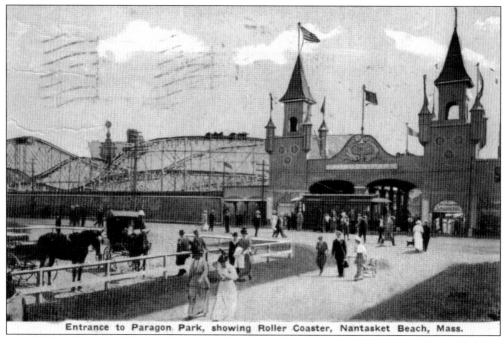

Entrance to Paragon Park, showing Roller Coaster, Nantasket Beach, Mass.

The early days of Paragon Park, which opened in 1905, consisted of more of an Epcot Center or world's fair theme than a typical amusement park of today. While thrill rides certainly came to exist, George A. Dodge and the promoters of the park hoped that they could strike a balance by bringing the people of the world to Hull, to see the wonders of the world. The original entrance to the park, shown here, attempted to give the sensation that something wonderful awaited beyond the gates.

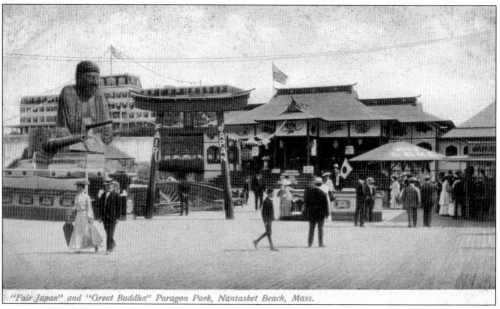

"Fair Japan" and "Great Buddha" Paragon Park, Nantasket Beach, Mass.

Once inside the park, visitors could move from exhibit to exhibit seeing the then-strange and unfamiliar world of the Far East and experiencing what it must have been like to be caught in the great Johnstown, Pennsylvania, flood of May 31, 1889.

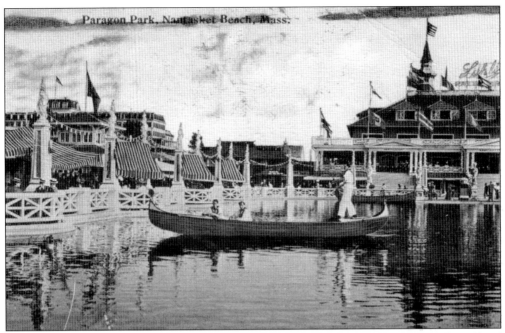

Paragon Park, Nantasket Beach, Mass.

A central lagoon, highlighted by an electric light tower boasting 50,000 shining bulbs, offered the opportunity to imagine being escorted through the canals of Venice serenaded by gondoliers. The park's owners spared no expenses in making the illusion complete, importing real gondoliers from Italy to perform at the park.

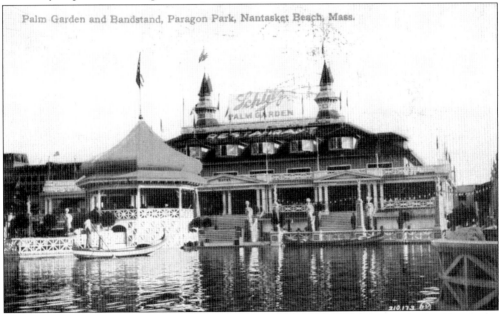

Palm Garden and Bandstand, Paragon Park, Nantasket Beach, Mass.

Of course, no amusement park of the day would be complete without regular band concerts and a beer hall. Paragon Park evolved with the times, surviving several major fires, ultimately closing and being sold at auction in pieces in the 1980s. The Paragon Carousel, with its flying and stationary horses and its twin Ben Hur chariots, remained in Hull after the auction, the last major reminder of 85 years of summer fun.

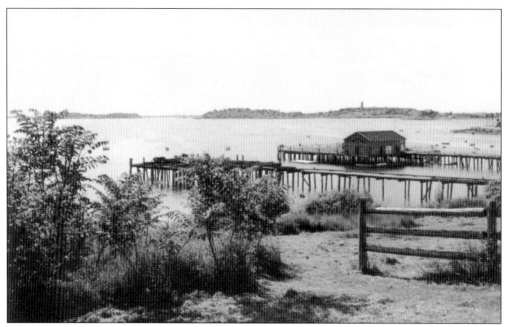

When a town stretches for seven miles into the ocean, it potentially has many wondrous spots. The wharf on the bay side of A Street (the alphabet streets in Hull run east to west across the peninsula, mostly from the beach to the bay) once served as a coal wharf for former police and fire chief John L. Mitchell. Today it is a beautiful spot for fishing, and a place where youngsters leap off the pier on hot summer days.

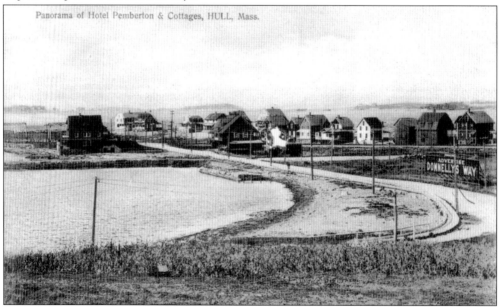

Panorama of Hotel Pemberton & Cottages, HULL, Mass.

The Pemberton section of town, where Hull High School now stands, is home to Coast Guard Station Point Allerton, one of the busiest search and rescue stations in the country, and Hull Wind I, a pioneer wind power station for Massachusetts. Because of the salt works that operated here at the beginning of the 19th century, the area was historically known as Windmill Point before the new turbine was erected.

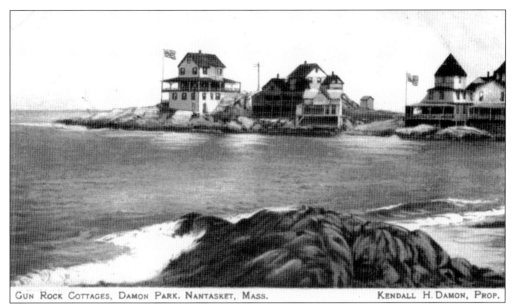

GUN ROCK COTTAGES, DAMON PARK. NANTASKET, MASS. KENDALL H. DAMON, PROP.

Gun Rock Beach derives its name from the scoter duck hunters, or "coot gunners," that took advantage of its positioning along migration routes to bring down the birds for boiling in coot stews. Capt. Joshua James and the local lifesavers launched their surfboat from here during the Portland Gale of 1898 to save the crew of the *Lucy Nichols*, and rumrunners, the Coast Guard, and the local police had a standoff here during Prohibition.

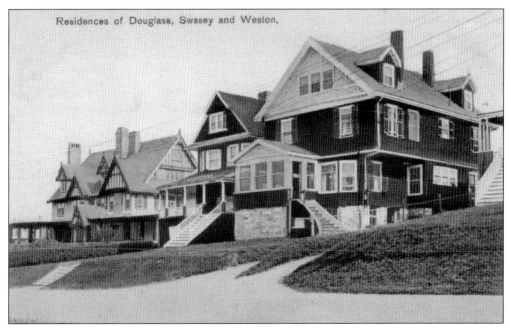

Residences of Douglass, Swasey and Weston.

Hull, like many coastal Massachusetts communities, became a playground for the rich and famous of the late 19th and early 20th centuries. The house on the far left, once the home of a gentleman named James Douglas, became the summer home of Mayor John "HoneyFitz" Fitzgerald of Boston, the grandfather of Pres. John F. Kennedy. Kennedy's brother, Joseph P. Kennedy Jr., was born in Hull, while HoneyFitz tossed a football with young boys on Nantasket Beach.

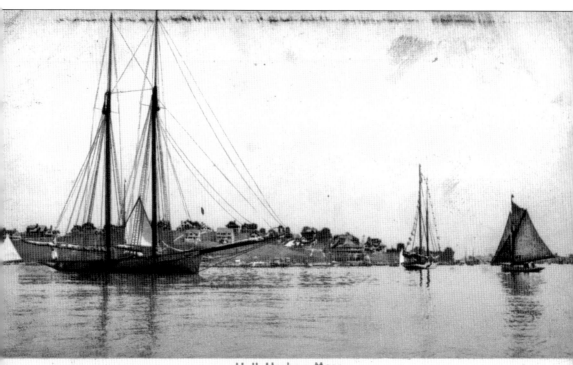

Hull Harbor Mass.

Hull's heyday came in on the tide of steamboats and trains, and ebbed away with the arrival of the automobile. The American spirit of exploration began to draw people ever farther away from the cities in search of relaxation and adventure, meaning that places like Hull, Winthrop, and Revere, while still attractions, no longer held the mystique they once did. By the 1930s, steamboat lines and railroads were shutting down, and the grand hotels of the beaches were watching their better days fly past. Yet, the lure of the beach in summer remains, and Hull's three-and-a-half miles of it still brings great crowds to the town in summer. There are no more screams from the diving roller coaster, nor hawking calls from the vendors on Peanut Row, but the crash of the waves, the seagull's cry, and even the stirring sounds of the carousel's military band organ can still be heard on any given summer's day.

Six

From Hingham to Quincy

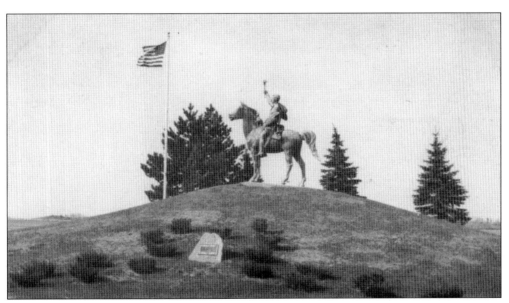

The Nantasket peninsula shields the coastal towns of Hingham, Weymouth, and much of Quincy, from the Weir River to the Neponset River, from incursions from the Atlantic Ocean and bears the brunt of northeast storms that are known to strike the region from time to time. As such, the histories of the shorelines of these communities have less to do with shipwrecks and lifesaving than they do with entrepreneurialism, industry, and relaxation. Hingham Harbor is known for its beautiful sandy beach, sailing clubs, and views of World's End Reservation and the Hingham Harbor Islands—Button, Ragged, Sarah, and Langlee. It is also known for its 1929 war memorial, *Victory*, more colloquially known as "Iron Horse." The monument stands on the former location of the Hingham Yacht Club.

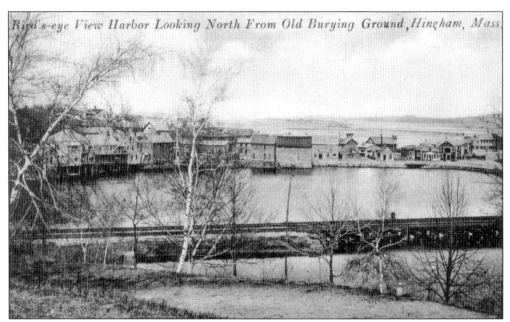

Bird's-eye View Harbor Looking North From Old Burying Ground, Hingham, Mass.

Visitors from the Hingham of yesteryear might not recognize their town today, at least not the harbor district. For, while the town has retained much of its historic flavor, its waterfront area has changed dramatically. The Mill Pond, which Peter Hobart and others discovered in 1633 and that once powered the town mill, was filled in 1952.

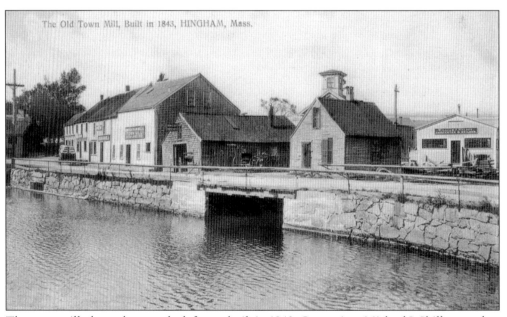

The Old Town Mill, Built in 1843, HINGHAM, Mass.

The town mill, shown here on the left, was built in 1843. One writer, Michael J. Shilhan, author of *When I Think of Hingham*, reminisced in 1976 about catching shrimp behind the mill as a young boy and waiting for the tide to come in to catch "smelt, eel, mackerel, herring, flounder, and sometimes cod." Much of the old Mill Pond area today is now parking for the Hingham Harbor business district.

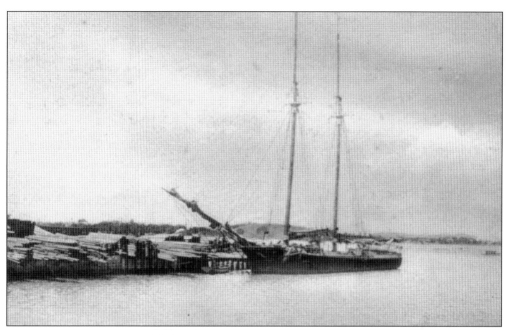

Out on Summer Street, Kimball's Wharf epitomized the waning years of the 19th century, a time when wooden schooners carried lumber up and down the coast for housing construction. It was a race to see what would wear out first, the old ships, or the lumber supplied from local forests.

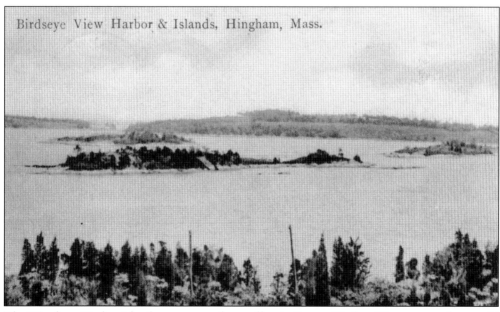

Birdseye View Harbor & Islands, Hingham, Mass.

The Hingham Harbor islands are among the smallest in Boston Harbor. Yet not even they could escape the hand of development. In the late 1800s, Ragged Island (the others being Sarah, Langlee, and Button) was home to a restaurant and observation blinds, possibly for use by hunters.

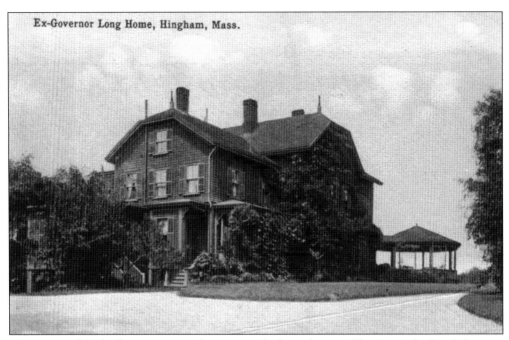

Ex-Governor Long Home, Hingham, Mass.

The scenes of the harbor were second to none, which is why men like Gov. John Davis Long, a Hingham resident who also served as secretary of the navy under Pres. Theodore Roosevelt, built their homes overlooking the area. The house was torn down in the 1960s, but 11 surrounding acres were given to the town of Hingham for use as a bird sanctuary.

Rocky Neck, World's End Farm, Hingham, Mass.

World's End Farm, on the west side of the outlet of the Weir River, is a well-known birders' paradise, a major stop along the migratory route of many species. Not bad for a site that almost became the home to the United Nations in 1945, or a nuclear power plant in 1965. Today the former farmland is kept open as a wildlife sanctuary by The Trustees of Reservation (TTOR).

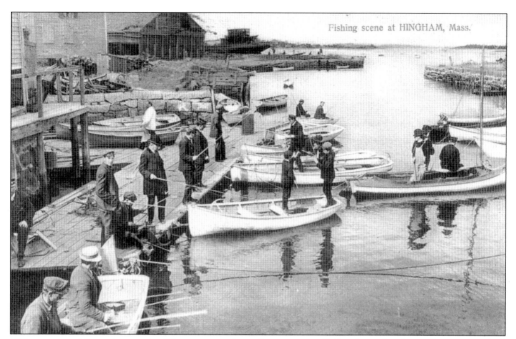

Of course, with such wonderful access to the calm waters of Hingham Harbor, that meant that both onshore anglers and boat-bound fishermen alike could satiate their needs to drown worms and reel in fish. Smelting off Beal's Wharf offered those opportunities.

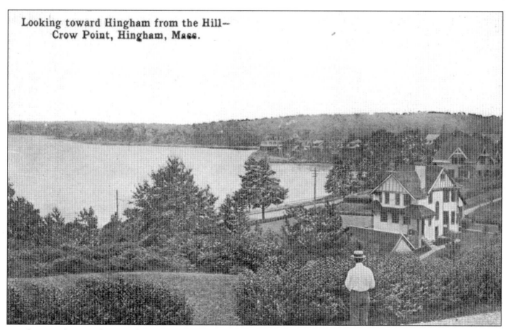

Farther to the northwest along the shore, Crow Point completes the western boundary of Hingham Harbor. Visitors from Boston who opted against the honky-tonk atmosphere of Nantasket for a more subdued vacation venue chose the splendor of Crow Point's Rose Standish Hotel and the bowling alleys, clambakes, and open air music of Melville Gardens.

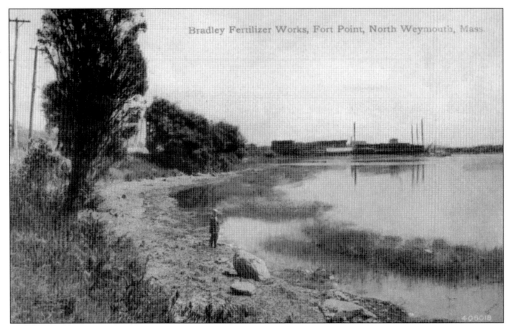

William L. Bradley was a pioneer in the chemical fertilizer business, opening a factory in Weymouth in the 1860s, but had operating plants in Cleveland, Ohio; Charleston, South Carolina; Baltimore, Maryland; and Cateret, New Jersey, as well. His company purported to be one of the largest of its kind in the world.

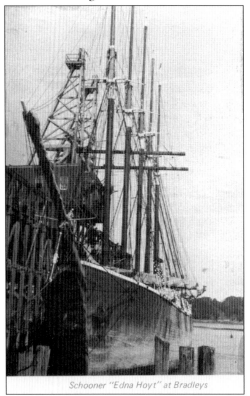

Schooner "Edna Hoyt" at Bradleys

The presence of the five-masted schooner *Edna Hoyt* at Bradley's wharf signified big business. The *Edna Hoyt*, built in Boston in 1920, carried on trade internationally, with stops in Puerto Rico; Halifax, Nova Scotia; and even south Wales in England. After a harrowing storm event in November 1937, during which the *Edna Hoyt* had to be towed into Lisbon, Portugal, by a Norwegian steamer, it was condemned and sold for $3,500. The *Edna Hoyt* was the last of the 58 five-masters built on the East Coast between 1888 and 1920.

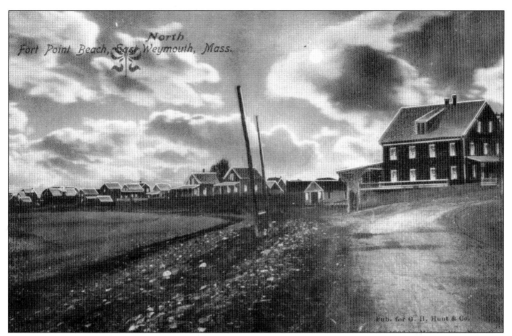

Coming west along Eastern Neck from the Bradley Fertilizer Plant, one eventually passes Fort Point and Fort Point Beach. The Bower House Inn, on the right, at the intersection of River and Fort Point Roads, was another of the shoreside attractions of the South Shore.

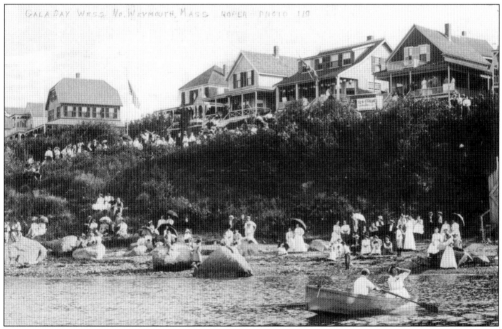

Traveling further west, one finds Wessagussett Beach, which bears the name of the 1622 settlement that caused the first blood to be shed between the local Native Americans and the first European settlers of the New World. When news of a plot to destroy the Wessagussett settlement reached Myles Standish, the military leader of Plimoth Colony, he set out with eight men to stop it cold, resulting in the deaths of three of the natives.

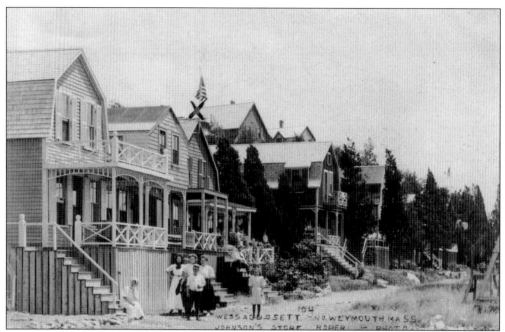

No lingering aftereffects of the altercation seem to haunt the Wessagussett shore today, nor did they in the early 1900s. Like many spots along the coast, cottagers built their seasonal homes as close to the water as possible. Stretching from Weymouth's Great Hill to King's Cove, Wessagussett Beach remains a wonderful spot to catch some rays along the edge of the outlet of the Fore River.

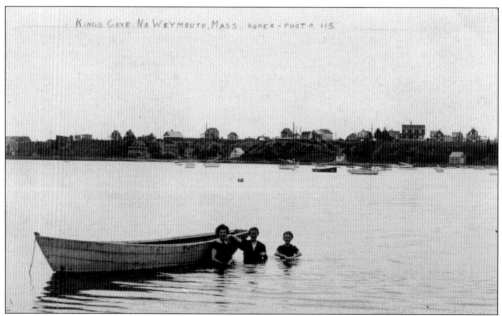

King's Cove Beach, on the eastern shore of a horseshoe-shaped indent in the North Weymouth shoreline, today is a neighborhood beach without parking, but at least the cove itself can be accessed by water. Just to the west of this scene (the right side of the postcard) is the confluence of the Fore and Town Rivers.

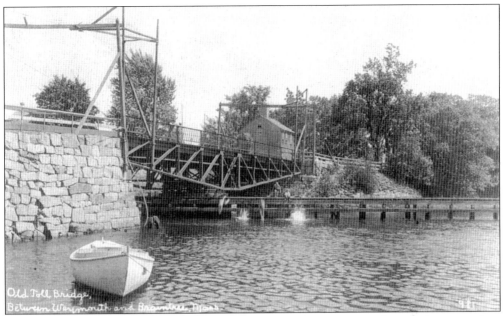

One should try not to blink when passing over the line from Weymouth to Braintree, or they might miss the entirety of the Braintree shoreline, along the Fore River.

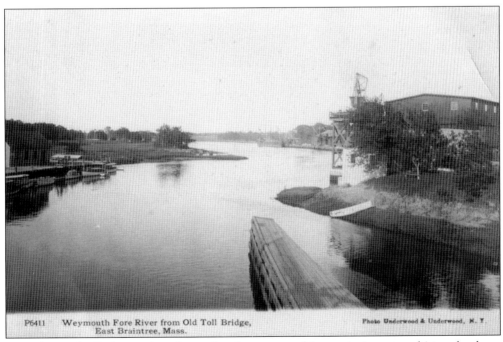

P6411 Weymouth Fore River from Old Toll Bridge, Photo Underwood & Underwood, N. Y.
East Braintree, Mass.

Considering the Braintree shore has such a short geographic run, its impact on history has been very long. It was here that Thomas A. Watson, he of telephone inventor Alexander Graham Bell's "Watson, come here, I need you," fame, began work on his very own experiment; a shipbuilding yard that became the largest of its kind in America in 1901.

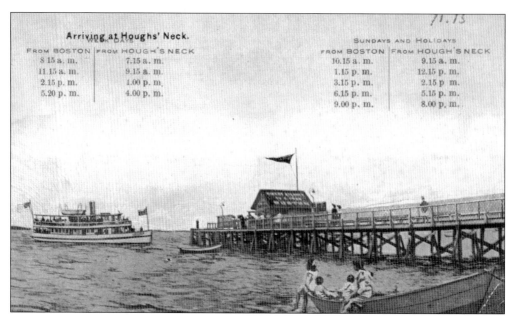

Arriving at Houghs' Neck.				SUNDAYS AND HOLIDAYS	
FROM BOSTON	FROM HOUGH'S NECK			FROM BOSTON	FROM HOUGH'S NECK
8.15 a. m.	7.15 a. m.			10.15 a. m.	9.15 a. m.
11.15 a. m.	9.15 a. m.			1.15 p. m.	12.15 p. m.
2.15 p. m.	1.00 p. m.			3.15 p. m.	2.15 p. m.
5.20 p. m.	4.00 p. m.			6.15 p. m.	5.15 p. m.
				9.00 p. m.	8.00 p. m.

Quincy's Hough's Neck had everything a seaside tourist could want at the beginning of the 19th century, including easy access by water from the city of Boston. The *Comet* and other ferries carried passengers from Boston's Northern Avenue Pier to Quincy's public dock at the eastern end of Bay View Avenue, near the Quincy Yacht Club. The pier was built in 1911.

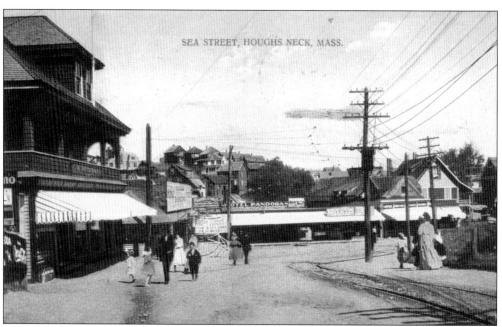

Much of the action of Hough's Neck took place on Sea Street, where the Sea Street Theatre could be found, where one could catch the earliest moving pictures; Taylor's ballroom and bowling alley; the Boston Candy Company; and Arthur Turner's Shooting Gallery and Popcorn Stand. If one could not find what they were looking for at Hough's Neck, they would have trouble finding it anywhere.

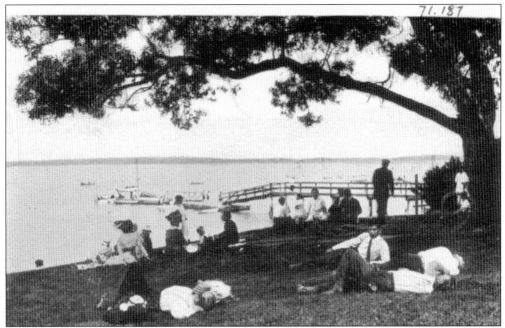

Of course, one would be hard pressed to find any level of stress at Hough's Neck, if that was what they were looking for at the beginning of the 20th century. As if a steamboat ride through the Boston Harbor islands was not enough of a pleasurable experience, one could add to the experience by waiting for the boat under the drooping arms of a shady willow tree.

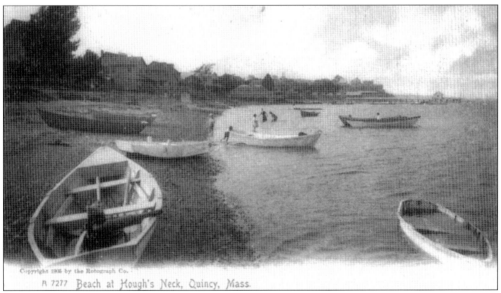

Copyright 1906 by the Rotograph Co.
A 7277 Beach at Hough's Neck, Quincy, Mass.

And, of course, Hough's Neck had beachfront as well. Doctors prescribed stays along the shoreline as curatives during the Victorian Era, and there can be no doubting that some old-timers still felt that a visit to the seashore had salubrious effects well into the 1900s. Saltwater bathing and fresh ocean air were supposed to reinvigorate the body, if not the mind and soul.

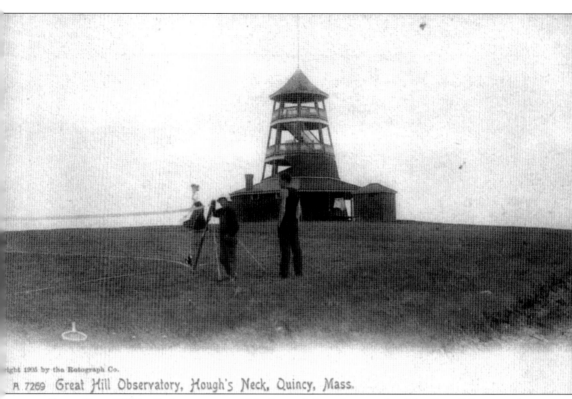

A 7269 Great Hill Observatory, Hough's Neck, Quincy, Mass.

From Great Hill in Quincy, one could look south into the mouth of the Fore River, southeast to the Wessagussett shore and Fort Point in Weymouth, east to the mouth of the Weir River, northeast directly at the western end of Peddocks Island, and north and westward into Quincy Bay. And out there, beyond Moon and Long Islands, the hardworking inner harbor began, along the Dorchester shoreline. For some travelers, there was no place in the world that matched the splendor of the South Shore; of course, they had their counterparts that would say the same about the North Shore. But, no matter how one looked at it—from the top of Boston Light to the top of Great Hill—the South Shore had a lot to offer when the postcard was king.

Seven

THE FORE
RIVER SHIPYARD

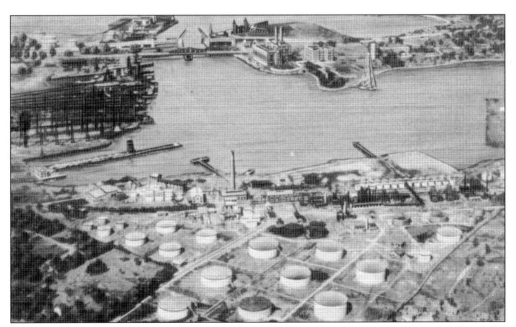

Life on Boston Harbor was not all play for everybody, for while the yachtsmen sailed and the beachgoers soaked in the sun, the shipyard workers toiled at their tasks on the same waters. The mouth of the Fore River, shown here, separates the city of Quincy on the left from the town of Weymouth on the right. Shipbuilding represented, by far, the greatest industrial activity on the Fore River. Thomas A. Watson, the man who received the first telephone call from Alexander Graham Bell, located his shipbuilding plant here in 1899 after moving his enterprise from East Braintree. This business grew to become one of the biggest shipbuilding plants in the country.

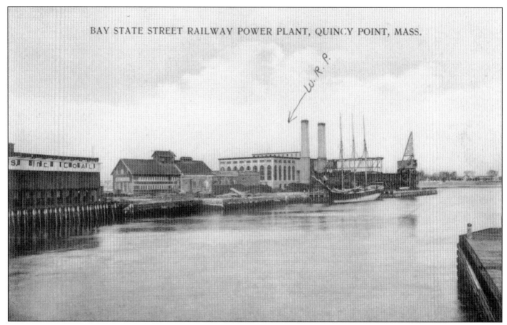

In the beginning of the 20th century, electric power spread until, by the 1920s, virtually all gas–lit houses were electrified. With electricity came the power plant and coal driven turbines. The coal schooner tied at the Quincy Point power plant in this scene will be replaced, by mid-century, by the steamed-powered ship, and oil will replace coal in most power plants.

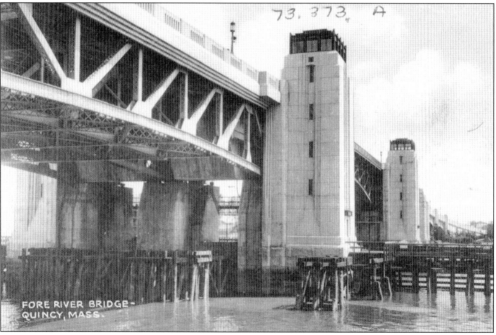

This version of the Fore River Bridge was completed in 1936 to replace the old swing bridge built by the shipyard after it had moved from East Braintree. This bridge was built to accommodate increased and larger ship traffic, as well as automobile traffic on Route 3A (Washington Street). The bridge was taken down in 2002, and a replacement is being constructed.

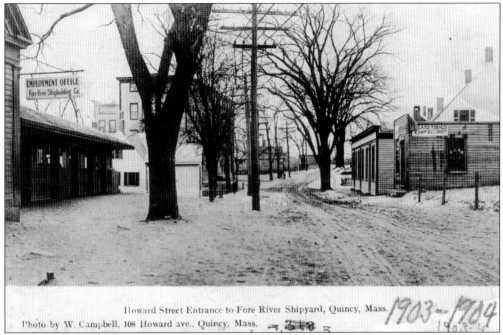

Howard Street Entrance to Fore River Shipyard, Quincy, Mass. *1903~1904*
Photo by W. Campbell, 108 Howard ave., Quincy, Mass. *3,568* *1903-4*

This humble 1904 entrance to the Fore River shipyard, with its employment office to the Fore River Shipbuilding Company, gives no hint of the large enterprise that will soon develop. The yard would go on to employ more than 20,000 people during World War II and build many famous ships.

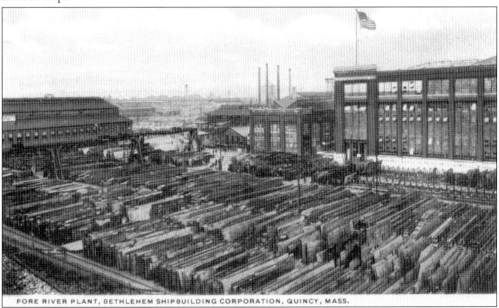

FORE RIVER PLANT, BETHLEHEM SHIPBUILDING CORPORATION, QUINCY, MASS.

This card shows the yard of steel, with a crane that carried that steel for use in ship construction. The shipbuilding business that operated in the yard had different owners over the years. In 1885, it was the Fore River Engine Company. That company was sold in 1913, and became part of the Bethlehem Steel Company, eventually the Bethlehem Fore River plant. In 1964, General Dynamics Corporation acquired the plant. It closed in 1986.

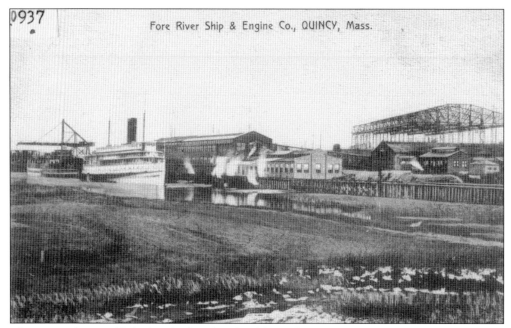

Fore River Ship & Engine Co., QUINCY, Mass.

This postcard was published in the first decade of the 20th century. The shipyard built two coastal steamers, the SS *Providence* (1905) and the SS *South Shore* (1906). One of the thrust works built over the shipways in order to easily move heavy material is also seen in this view. The thrust works were one of the landmarks of the shipyard.

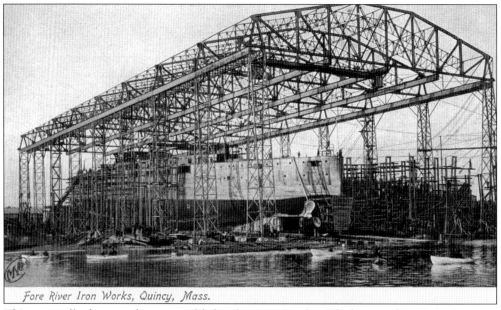

Fore River Iron Works, Quincy, Mass.

This postcard's photograph was most likely taken on a Sunday. The boats and canoe in the water could be the workers from the shipyard showing their wives and girlfriends what they do at work. The ship under construction appears to be a naval ship, likely one of the battleships built at the yard before World War I.

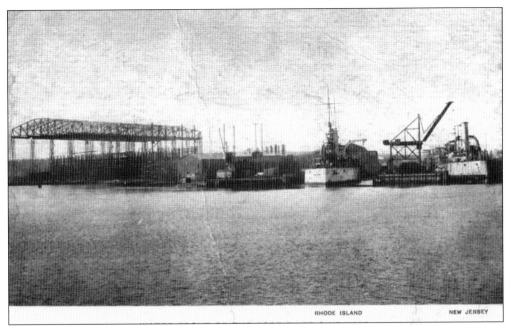

RHODE ISLAND NEW JERSEY

The USS *New Jersey* (BB-16) was launched in 1904. It is seen here with the USS *Rhode Island*. The *New Jersey* was a member of the Great White Fleet that sailed around the world in 1907 through 1909. In 1910 and 1911, the *New Jersey* was in Boston. During World War I, it brought troops to France. The *New Jersey* was decommissioned in 1920, and was sunk by the Army Air Corps under Gen. William Mitchell on September 5, 1923.

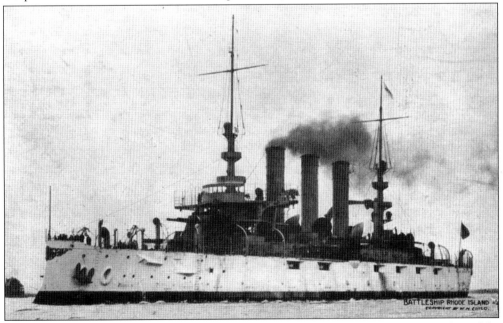

The USS *Rhode Island* (BB-17) was launched in 1904. The *Rhode Island* was also a member of the Great White Fleet sent around the world between 1907 and 1909 to show off American naval power. At the end of World War I, it was fitted out to carry 5,000 troops home from France. It was decommissioned and scrapped in 1923.

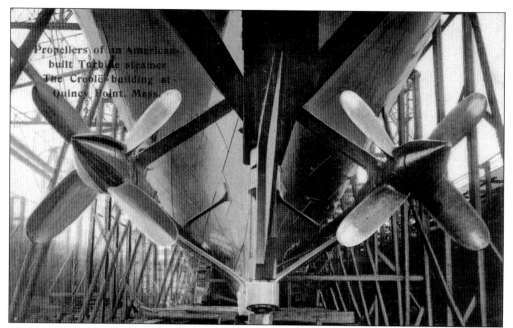

The South Pacific Company had a freighter, the SS *Creole*, built at the Fore River plant. A substitute engine was installed for the one that was specified, but did not give the performance required. South Pacific sued the plant and won; thus the proper engines were installed. Pictured are the giant propellers of the *Creole*.

The Fore River Shipyard built two of the five battleships of the Virginia Class (1906–1907). The ships' speed was 19 knots. They had four 12-inch guns, and eight 8-inch guns, and were mostly known for their membership in Theodore Roosevelt's Great White Fleet (1907–1909), which sailed around the world, and was enthusiastically welcomed by the people of Japan.

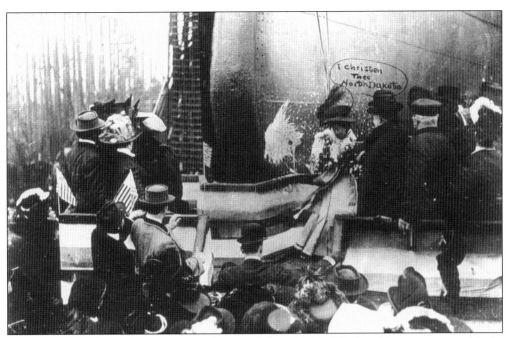

On November 10, 1908, Mary Benton christened the USS *North Dakota*. There were two ships in this class. The other was the USS *Delaware*. These ships were the first of the American Dreadnoughts. The ships could top 20 knots, fitted out with 10 twelve-inch guns and 14 five-inch guns each. By 1920, they were obsolete. The *North Dakota* was scrapped in 1931.

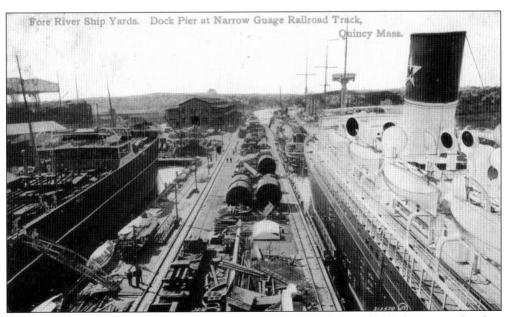

Ships were finished (fitted out) at dockside. It is hard to identify the ships in this postcard as they are in different stages of being finished. The passenger ship was most likely there for repairs. There was a steam locomotive that worked the yard on the narrow tracks visible in the photograph.

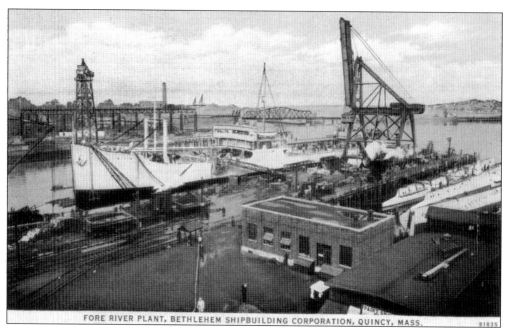

FORE RIVER PLANT, BETHLEHEM SHIPBUILDING CORPORATION, QUINCY, MASS.

In this scene, the tracks of the narrow gage have two flatbeds parked on them. The yard is finishing a tanker. Early in the 20th century there were few tankers on the water. At the Fore River yard two were built in 1916 and four in 1917.

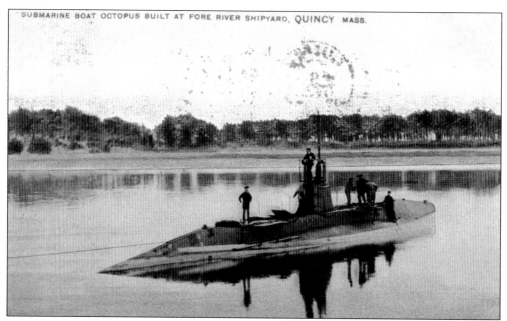

SUBMARINE BOAT OCTOPUS BUILT AT FORE RIVER SHIPYARD, QUINCY MASS.

The submarine *Octopus* (SS-9-C-1) was launched in 1908. It served in waters off Cuba and Panama until it was sold in 1920. The Fore River yard built many submarines in the first decade of the 20th century. The yard built five for the Japanese Navy in 1904. In the next six years, 21 submarines were built for the U.S. Navy at Fore River.

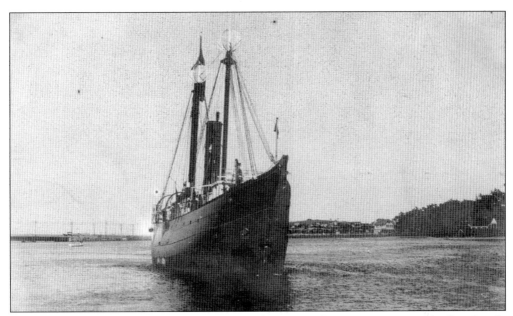

The Fore River yard built several lightships for the U.S. Light House Service in the first decade of the 20th century. The ships were numbered, not named. The first ship, built in 1901, was No. 72. Subsequent lightships built were 91, 92, and 93, which became the Swiftsure Bank Lightship that served off the coast of Washington State.

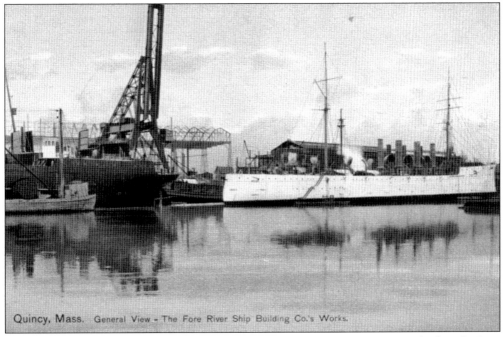

Quincy, Mass. General View - The Fore River Ship Building Co.'s Works.

The ship in this postcard is most likely the scout cruiser USS *Salem* (CL-3). It was built at the Fore River yard and launched in 1907, it would later serve in World War I as a convoy escort and in other anti-submarine missions. It was scrapped in 1929. Its namesake, USS *Salem* (CA-139), also built in the yard, is a museum ship, highlighting the history of military shipbuilding at Fore River.

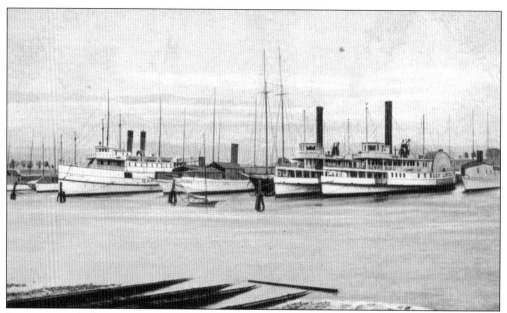

Summer was the busiest time of year for these excursion boats and coastal steamers. In the winter, when few people were thinking about spending time on the beaches of the South Shore, safe storage was required. This spot on the Fore River, just by the shipyard, provided just such a winter resting place.

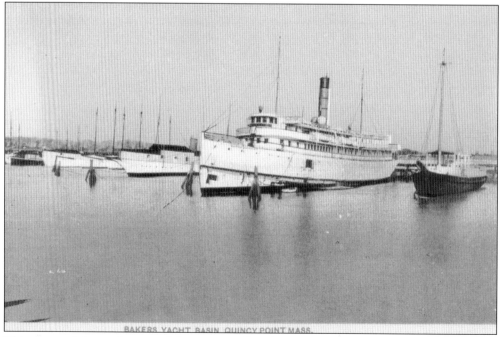

This postcard shows the rest of the summer fleet in winter quarters at Baker's Yacht Basin, Quincy Point, just by the Fore River Shipyard. Although not majestically landscaped, nor beset with sweeping panoramic vistas, or studded with picturesque lighthouses, the industrious scenes at Fore River made for inspiring postcard imagery for the citizens of an America on the verge of becoming a world power.

Eight

THE WORKING
WATERFRONT

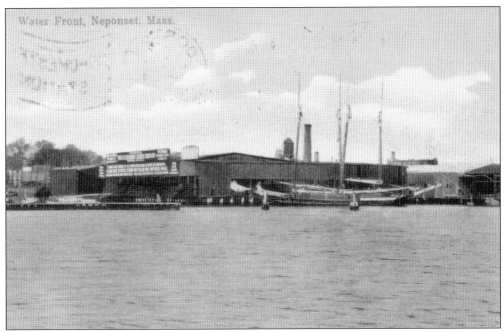

Water Front, Neponset, Mass.

North and west of the Fore River, the Boston Harbor waterfront reflects the density of the city that gives it its name, both in commerce and recreation. The Neponset River separated Norfolk County, Quincy, and Milton from Suffolk County's Dorchester. Native Americans paddled down the Neponset to trade with the English on Thompson's Island in the 1600s. In the 1800s, the river became industrialized with companies such as the Baker Chocolate Mills. On the Dorchester side, a whaling enterprise was established at Commercial Point as well as A. T. Stearns' Lumber Company and the George Lawley shipyard at Port Norfolk.

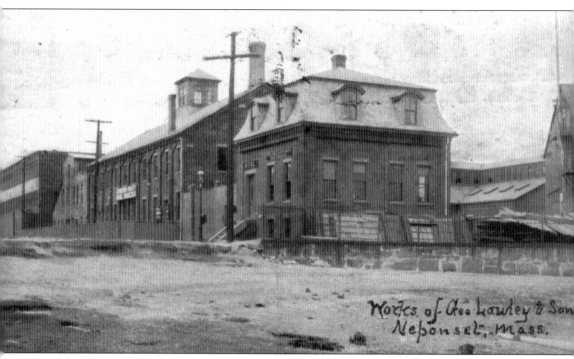

It was in 1910 that the George Lawley and Son Shipyard moved to this site at Port Norfolk in the Neponset section of Dorchester. The buildings in this view are on Ericsson Street and were built for the Putnam Nail Company, which Lawley later owned. In the 1860s, Putnam produced forged horseshoe nails. Lawley's company was established in Scituate in 1866 by George Lawley Sr., an Englishman who had worked for 15 years for Donald McKay. The yard was famous for its racing yachts as well. Edward Burgess (1848–1891) designed the sloop *Puritan* that won the America's Cup in 1885, and the sloop *Mayflower* that won the 1886 race; both yachts were built at Lawley's shipyard. In World War II, a type of gunboat was designed and built by the Lawley yard, Landing Ship Support Large (LSSL). The Lawley yard built 130 of these ships. The shipyard went out of business just after the war ended.

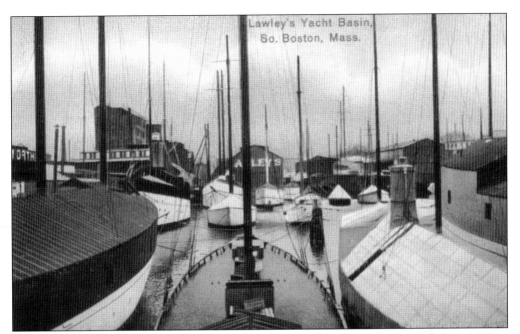

This is Lawley's shipyard when it was located in the area of the Reserve Channel, from 1902 to 1910. This winter scene, with the boats covered, shows the type of sailboats popular as pleasure craft at the beginning of the 20th century. The postcard also shows the crowded conditions that motivated the eventual move to Port Norfolk in Dorchester.

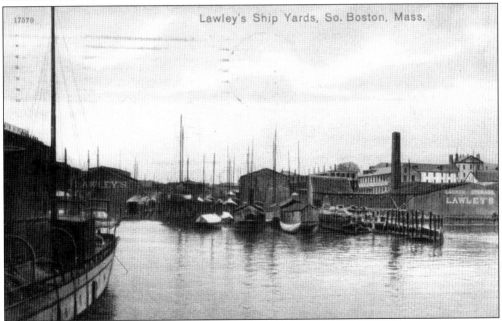

The buildings in the background to the right of this postcard are part of the old Suffolk County House of Correction. In the foreground is the Lawley shipyard. The site was used until the 1850s for the Suffolk County House of Correction when the inmates were moved to Deer Island. The availability of some of the house of correction land gave Lawley's shipyard some breathing room, but it was not enough, so they moved to Port Norfolk.

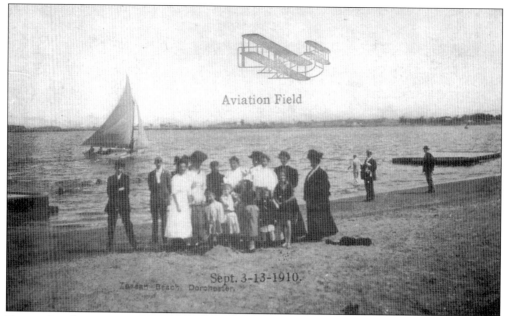

Tenean Beach is separated from Port Norfolk by a little inlet known as Pine Creek. The beach has a good view of the Squantum Point section of Quincy. From 1909 to 1912, summer aviation meets were held in Squantum; hence the stamp and date on the postcard. Many on this shore witnessed Harriet Quimby and her passenger William Willard fall to their death from their plane in July 1912.

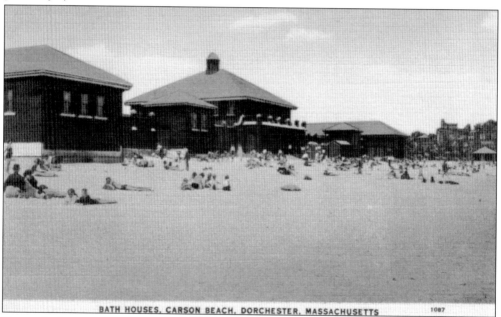

Boston had a strong understanding for the value and need of public parks. The Boston Park Commission put an idea of a marine park forth in the year 1876. Landscape architect Frederick Law Olmsted drew plans for Marine Park in 1883. Carson Beach was built on filled land on the Strandway (William J. Day Boulevard, 1950). The beach was complete with the building of the bathhouse, seen in this postcard, in 1922–1923.

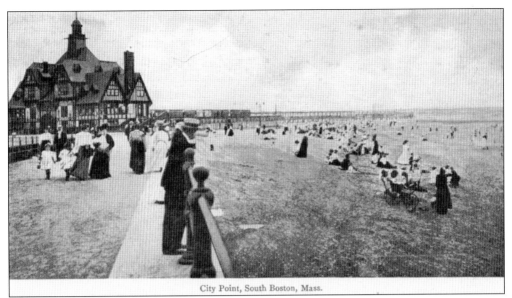

City Point, South Boston, Mass.

In the 1870s, City Point was built on the east end of South Boston. The site of Olmsted's Marine Park became the crown jewel of a park along the shores of South Boston and Dorchester. The incorporation of Castle Island and the circular Pleasure Bay helped to make this park a popular place. The half-timber building is a bathhouse modeled after the German pavilion at the 1893 Columbian exhibition.

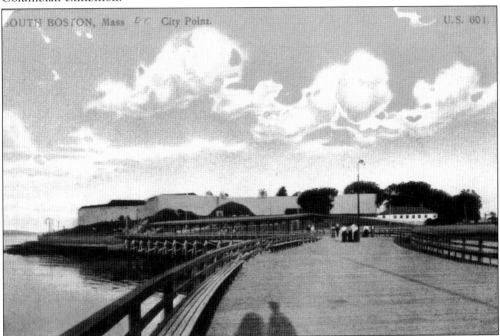

Postcard publishers are notorious for editing photographs and doctoring images. This postcard of the wooden causeway from City Point to Castle Island is unedited, for the shadow of the photographer and his camera are plainly visible. Harbor defenses have been there since 1634. The massive wall of Fort Independence dominates Castle Island. Fort Independence was built by the federal government from the 1830s until finished in the 1850s.

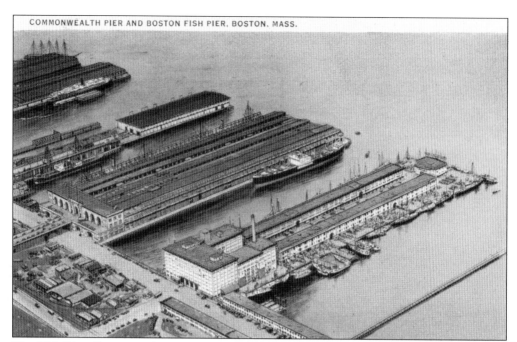

The Fish Pier (foreground) and the Commonwealth Pier were built in 1914 on Northern Avenue. Cold storage and ice making activities took place on the street side of the Fish Pier. The building on the other end is the Fish Exchange, where fish auctions were held. The freighter at Commonwealth Pier may be carrying wool. The wool business was located in South Boston.

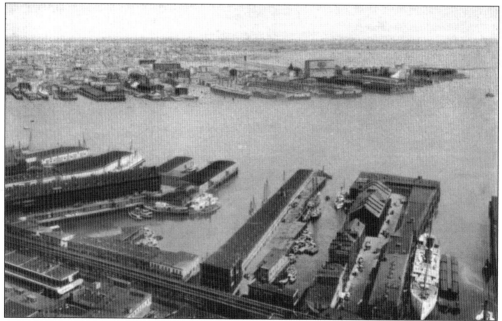

The steamer tied at Long Wharf is likely one of the New York boats. T Wharf, to the north, has a few fishing boats tied up. The next pier north is Commercial Wharf. The piers in East Boston have a steamer, possibility a Cunard ship. Atlantic Avenue was built in 1868 to ease traffic from north to south, cutting right through old wharves that were in its path.

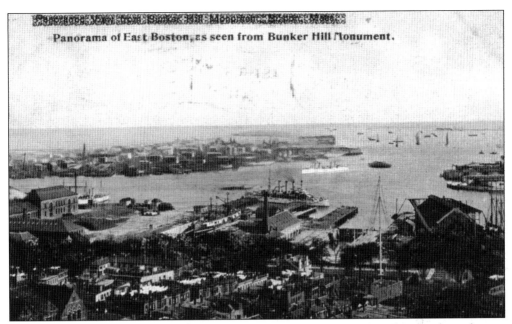

Panorama of East Boston, as seen from Bunker Hill Monument.

The Bunker Hill Monument (1843) and the customhouse tower (1915) were the only two places one could get an aerial view of Boston Harbor until the mid–20th century. The Boston Naval Ship Yard has a warship tied up in the center, possibly the cruiser *Tennessee* or the cruiser *Maryland*, as both were at the navy yard in the first decade of the 20th century.

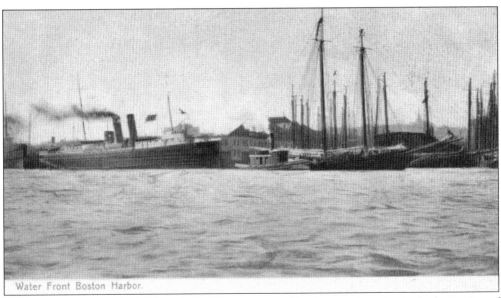

Water Front Boston Harbor.

The black steamer on the left is typical of the passenger ships in coastal service in the beginning of the 20th century. It is possibly one of the Dominion Atlantic Line steamers. One could take a boat to many locations on the east coast from Boston. The masts on the north side (right) are fishing schooners, and one can just make out the dome of the Massachusetts State House in the background.

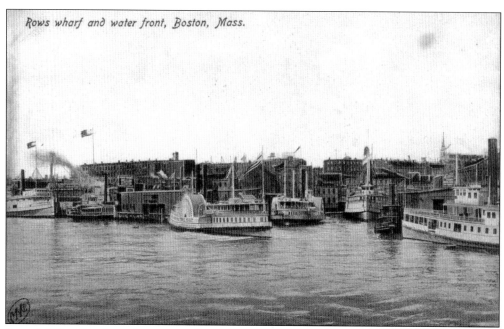

Rowe's Wharf has been the center of local boat travel for about 100 years. The large boat to the left is possibly the SS *City of Bangor*. In the center is the ferryboat of the Boston, Revere Beach and Lynn Railroad company. It is coming out between Foster's and Rowe's Wharf. The other boats belong to the Nantasket Steamship Company, which made daily trips to local points.

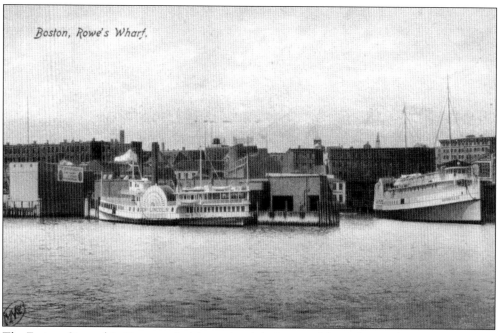

The Eastern Steamship Company's ship on the right is one of those that made runs to points in Maine. The steamboat *General Lincoln* made trips to Fort Warren on George's Island and served the town of Nahant along with the *Governor Andrew*. In the Colonial period, Rowe's Wharf was the site of the South Battery. The North Battery was in the North End at Battery Wharf.

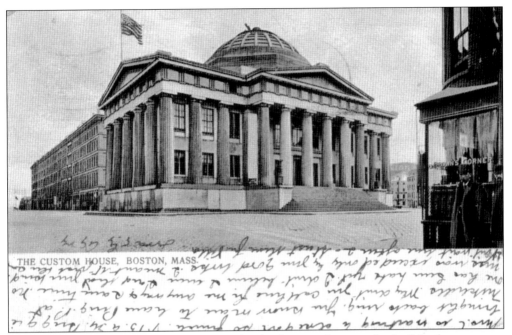

THE CUSTOM HOUSE, BOSTON, MASS.

The Custom Service, established in 1789, was the chief source of revenue for the federal government until 1913, when income tax began. This Greek–Revival building was designed by Ammi B. Young and built on filled land on State Street at the harbor's edge in 1847. The granite warehouse building behind the customhouse is the State Block designed by Gridley Bryant (1858). East of this building is Long Wharf and the harbor.

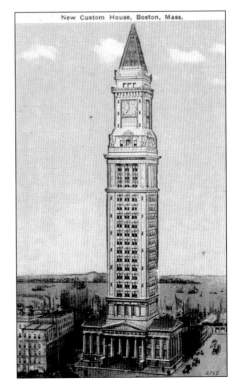

New Custom House, Boston, Mass.

Peabody and Stearns designed a tower to be built atop of the old customhouse in 1915. The description on the reverse side of the card reads, "U.S Custom House, Boston. Dating from 1847 its site was the head of Long Wharf. The new tower will reach 505 feet into the air and will have a total of 30 stories in all, this being the highest building in New England."

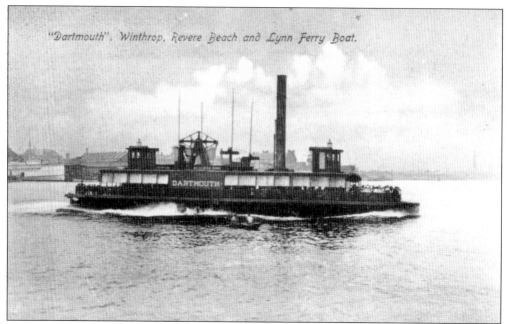

The *Dartmouth*, which was the Boston, Revere Beach and Lynn Railroad ferry, heads out between Rowe's and Foster Wharfs towards the Marginal Street pier in East Boston, where the railroad was located. The railroad was popularly known as the "Narrow Gauge." Service ran from 1875 through 1940.

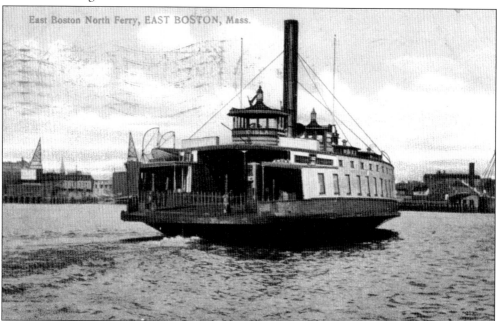

The North ferry, *Noddle's Island*, is headed to East Boston from Lincoln Wharf in the North End of Boston. These ferry boats ran for the People's Line, also commonly known as the north line, which started running in 1854. There were ferries running to Noddle's Island or East Boston since the 17th century. The automobile and the construction of tunnels under the harbor ended this type of service.

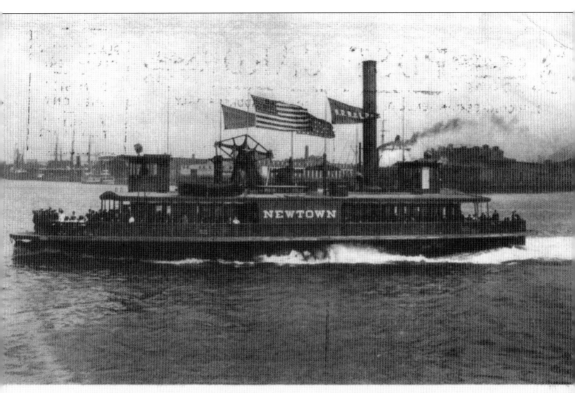

Boston, Revere Beach & Lynn R. R Ferry Boat.

A large crowd has come aboard the Boston, Revere Beach and Lynn Railroad company's ferryboat, *Newtown*. It is making its way across the harbor to its Boston slip on a summer day in the first decade of the 20th century. In the background, on the right, behind the white-hulled side-wheeler, you can see the hull and the stack of one of the steamships to dock on the East Boston waterfront.

97

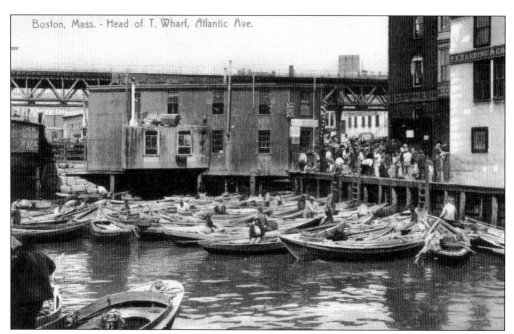

The boats in this postcard are those of the day fisherman. This part of the fishing business stayed at T Wharf, long after the large boats left. Recent immigrants, Irish and Italians, were those who earned their income this way. In the background is the Atlantic Avenue Elevated Railway.

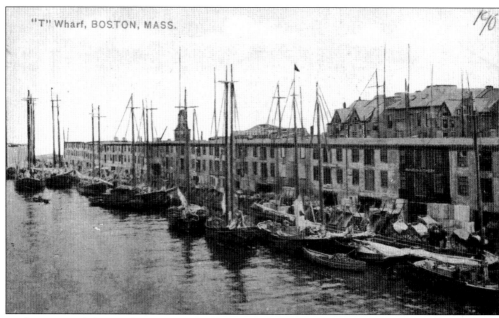

In this view of the north side of T Wharf, one can see the roof of the Custom House Block on Long Wharf in the background, and the cupola of T Wharf. There was a bell in the cupola that rang for the fish auction. Schooners of different designs and uses all landed their fish here. Boston was the market town for New England.

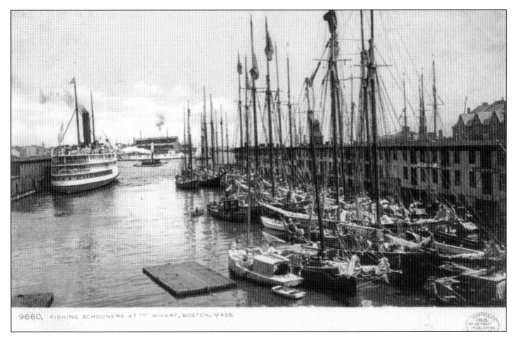

The steamer tied on the left in this postcard at Commercial Wharf is possibly the steamship *City of Rockland*. In the background one can see a grain elevator in East Boston of the Boston and Albany Railroad. Note the schooner in the foreground with its stacked dories.

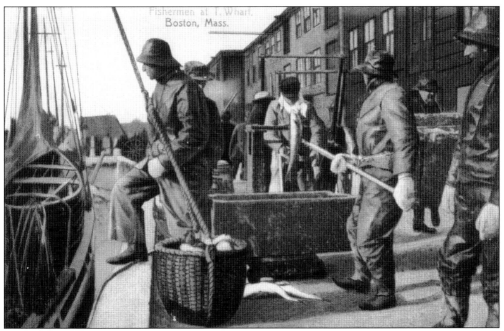

It looks like a cold and wet day when these men are landing their catch at T Wharf. Note there are two types of foul weather hats the men are wearing, the broad brim type and the typical Sou'wester.

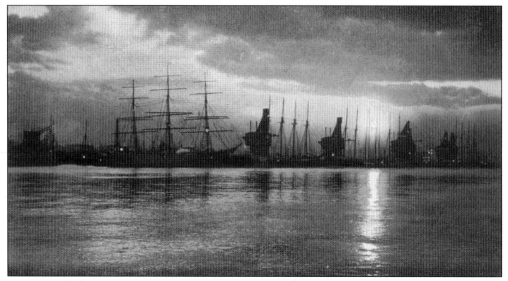

This moonlight scene puts a little romance on what otherwise is a dirty business, the business of coal. The angular structures on the shore are used to unload the coal ships. This scene is in Charlestown. It is ironic that coal, used for power at the time, was brought to port in the early 1900s on large sailing ships, long after most other ships were using coal for steam engines.

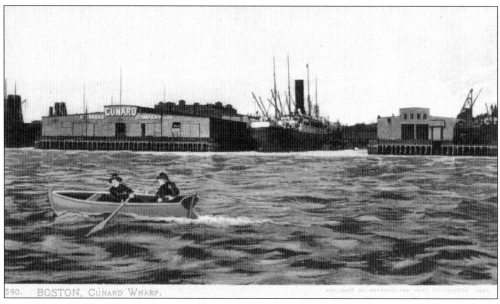

Cunard had the SS *Ultonia* (1899), SS *Saxonia*, and the SS *Ivernia* (1900) on the Liverpool-Queenstown-Boston run before the First World War. This dock is in East Boston across from Commonwealth Pier. The dock was also known as the Boston and Albany Railroad Dock from which Cunard had a free lease as long as there were enough exports. Many Europeans found their way to America on these ships.

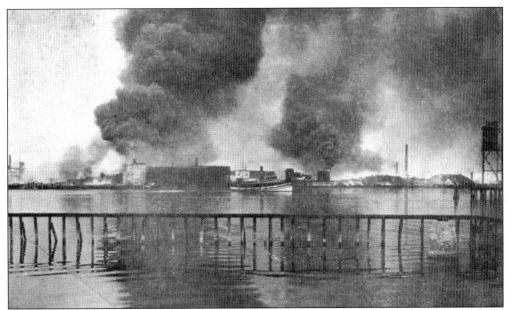

This postcard should be retitled the Great Chelsea Fire of 1908 in East Boston. The fire started on April 12, 1908, near the Everett line. It spread fast, and in about 10 hours consumed one-and-one-half miles by three quarters of a mile of Chelsea. The fire spread by embers, some of which crossed the Chelsea Creek and caught the Standard Oil plant in East Boston on fire.

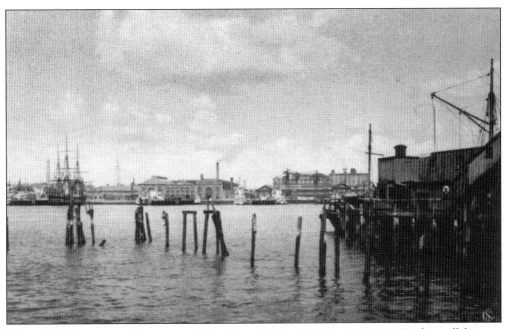

The *c.* 1934 image on this postcard is by Samuel Chamberlain (1895–1975), the well-known photographer of New England architecture and landscapes and author of *Historic Boston in Four Seasons* (1938) and others. The picture was made from the North End side of the harbor and shows the Charlestown Navy Yard, where one can plainly see "Old Ironsides."

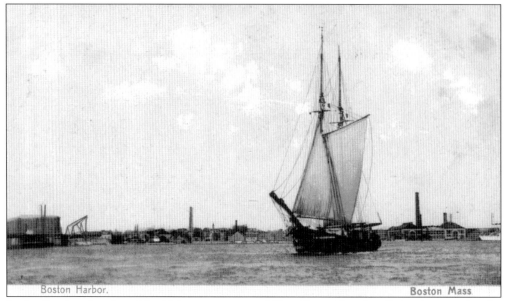

Boston Harbor. Boston Mass.

In the first few decades of the 20th century, some folks still could make a living in coastal trade. This two-mastered schooner, not likely a fishing boat, is making its way down harbor, perhaps after delivering lime from Maine or granite from Cape Ann. The Charlestown Navy Yard's machine shop is in the background.

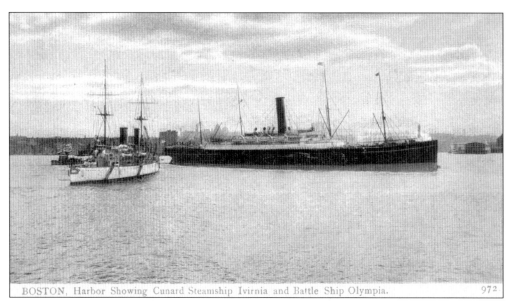

BOSTON, Harbor Showing Cunard Steamship Ivirnia and Battle Ship Olympia. 972

U.S. Navy cruiser USS *Olympia* (C-6) was the flagship of Commo. George Dewey in the blockade of Manila during the Spanish-American War (1898). The ship was in Boston in 1902, and is now a museum in Philadelphia. The SS *Ivernia* was built for the Cunard Line. It worked on the Liverpool-Queenstown-Boston route, was later made a troop transport in 1914, and was sunk by a German U-boat (*U-47*) off Greece in 1917.

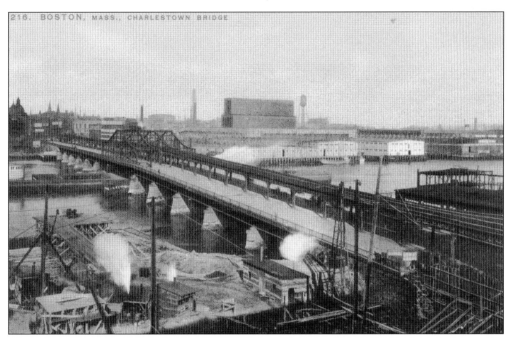

This bridge dates from 1899. The elevated section in the center is for the "el" line, to Sullivan Square, which was completed in 1906 and taken down in 1975. The docks to the right are the Hoosac Tunnel Docks. The White Star as well as the Warren shipping lines used these docks.

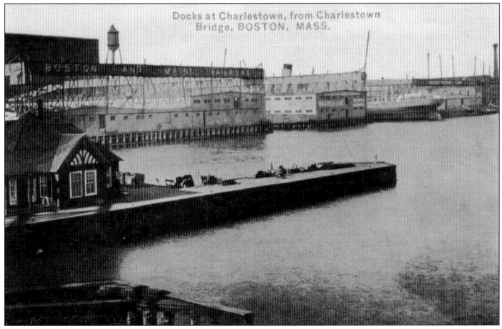

Docks at Charlestown, from Charlestown Bridge, BOSTON, MASS.

To the left is the control house of the Charlestown Bridge. The Boston and Maine Railroad owned the Hoosac Docks, once called Tudor's Wharf. The White Star Line used the dock for passenger service to the Mediterranean. The White Star ships on the Boston route were *Canopic II*, the *Arabic II*, and the *Republic*. A White Star Line ship is visible at the dock.

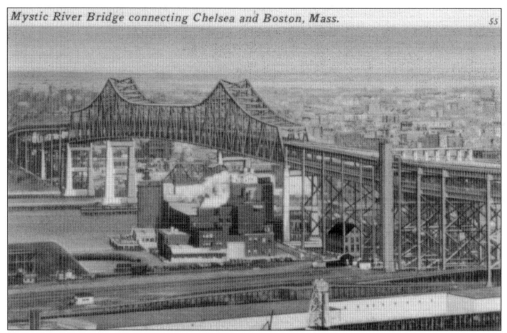

After World War II, the automobile was king. The ferryboats that took people between Chelsea and Boston are gone, as is the Narrow Gauge. The Mystic River Bridge was opened in 1950. Its height allowed shipping into the Mystic River and Chelsea Creek. The name of the bridge was changed to the Maurice J. Tobin Bridge in 1967.

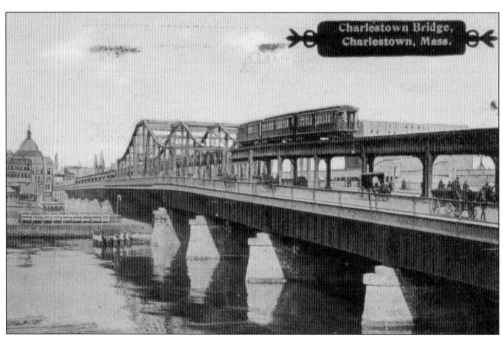

This postcard view of the Charlestown Bridge depicts morning rush hour traffic, heading toward Boston. This could simply be an indication of the postcard publisher doctoring the view to enhance sales. The scene is from around 1906, when the elevated railway was built.

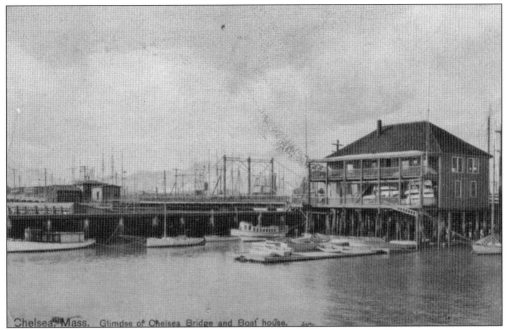

Chelsea Creek starts in Revere with the Mill Creek. It separates East Boston from Chelsea and flows into the Mystic River at the point of the bridge. Chelsea Creek has been an important industrial river and port facility since the 19th century. The river was also the site of the Chelsea Creek battle in the American Revolution.

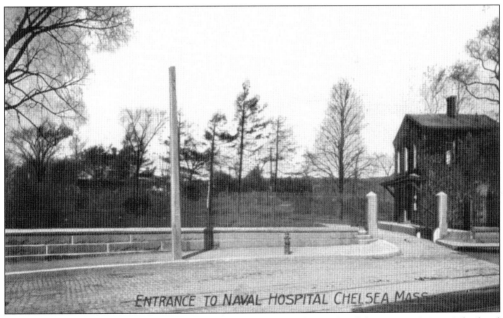

The site of the Chelsea Naval Hospital is a hill on the Chelsea side of the Mystic River. The land for this facility was acquired in 1823. The hospital was built in 1836 with money from the Naval Hospital Fund. This private source of funding prevented Congress from moving the hospital to one of the Boston Harbor Islands in 1884.

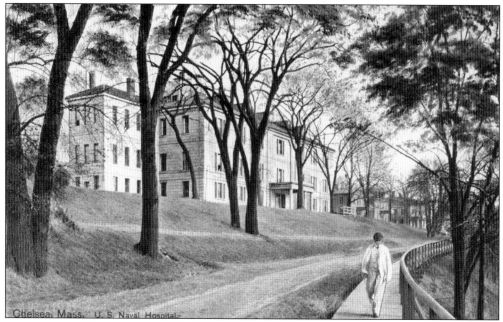

This is the 1832 Vermont granite building of the U.S. Naval Hospital in Chelsea. During the Chelsea fire of 1908, more than 12,000 casualties and homeless were cared for at this hospital. The hospital was overwhelmed during the 1917–1919 influenza epidemic. John F. Kennedy recovered here after his injuries suffered when USS *PT 109* was sunk in 1944 in the Pacific Theater of Operations. This hospital closed in 1977.

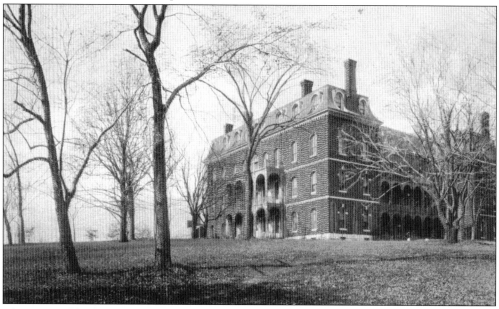

This mansard building was the U.S. Marine Hospital in Chelsea. The U.S. Marine Service was established in 1798 to take care of merchant seamen. The first hospital was opened on Castle Island in 1799, later moved to Charlestown Navy Yard, and then to its own grounds by the Chelsea Naval Hospital. The hospital moved again in 1940 to Brighton. The Marine Hospital Service became the Public Health Service in 1912.

Nine

THE CHARLESTOWN
NAVY YARD

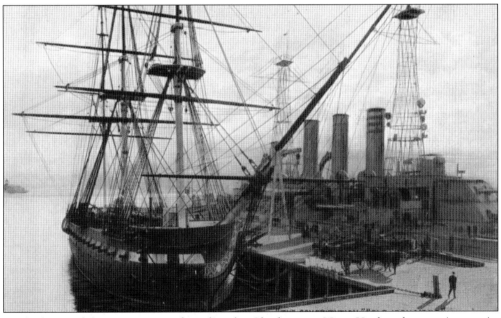

At the heart of the Boston waterfront lies the Charlestown Navy Yard, today a major tourist attraction. The navy yard was established in 1800 and was closed in 1974. The USS *Constitution* was launched from Edmund Hartt's yard in the North End in 1797. It still serves as a commission ship in the U.S. Navy. The *Constitution* has 44 guns, yet was no match to the heavy guns of the pre–World War I battleship berthed next to it in this postcard. At about the time this card was printed, *Constitution* had just been saved from fratricidal attacks. The secretary of the navy had proposed in 1907 that the ship be used for gunnery practice by other ships of the service. Local grassroots support stopped this event from taking place.

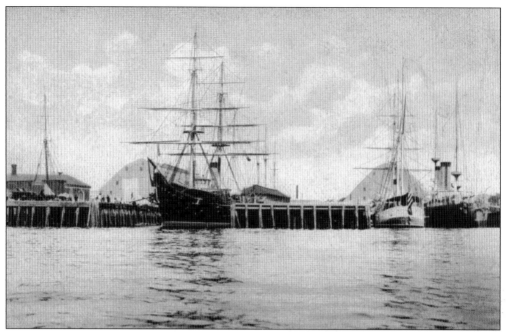

The structures with the sloping roofs in this postcard are ship houses. Commo. William Bainbridge introduced the concept of building a ship under the roof of an enclosure in 1813. Two of these three houses lasted into the 20th century, after the days of wooden warships had ended.

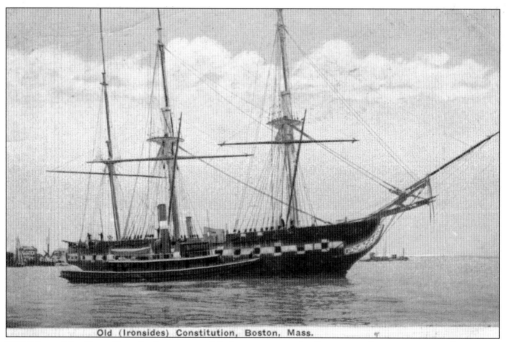

Old (Ironsides) Constitution, Boston, Mass.

"Old Ironsides," as *Constitution* was and is known, was in Portsmouth, New Hampshire, as a receiving ship from 1882 to 1897. It was later towed to Boston in preparation for its centennial celebration in that latter year. The shed that covered its top was removed and some rigging was added. A major restoration of the ship took place in 1927.

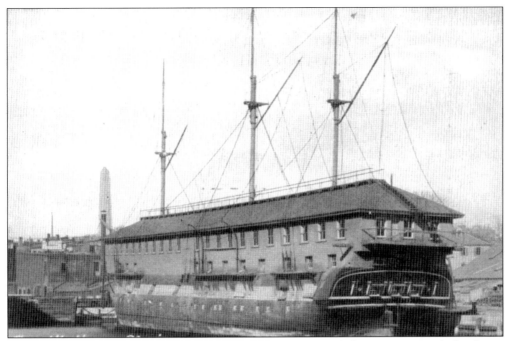

This is the USS *Constitution* as it looked when it was a receiving ship in Portsmouth for almost 20 years, and in Boston for 10 years. In 1907, the structure built over the top deck was taken off and it began to look like its old self again.

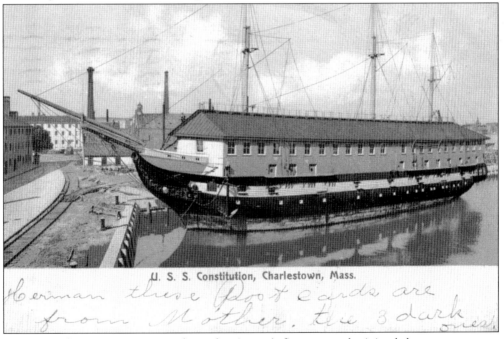

U. S. S. Constitution, Charlestown, Mass.

Herman these post cards are from Mother. the 3 dark ones.

Receiving ships were temporary barracks. A man's first stop as he joined the navy was on a receiving ship until the service could schedule his training or assignment. Personal and health checks would be conducted on such a ship. Receiving ships, although old and humble, had proud histories, such as that of the USS *Constitution*.

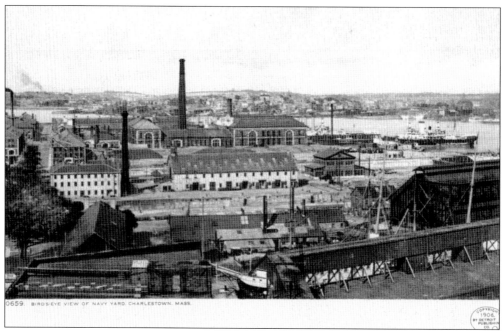

This postcard view looking north has Dry Dock 1 in the foreground. The granite building in the center to the left houses the dry dock pump. The building to the right is a workshop that relied on the pump engine to run machinery when it was not being used for the dry dock. The large machine shop, with its arch windows, can be seen in the background.

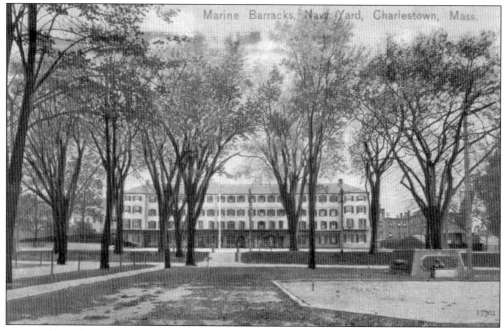

Marine barracks existed in the navy yard as early as 1809. These barracks were remodeled in 1823. This postcard shows the remodeled barracks as they looked around 1910, not very different than they looked after remodeling in the early 19th century.

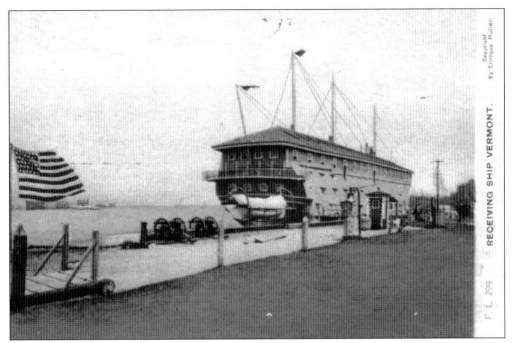

The receiving ship *Vermont* was laid down in Boston in 1818. It was not launched until 1848, by then an old and out of date ship. At the time of the Civil War, it was needed as a store ship and assigned to Port Royal, South Carolina. After the war, it became a receiving ship in the New York Navy Yard. The *Vermont* was condemned and sold in 1902.

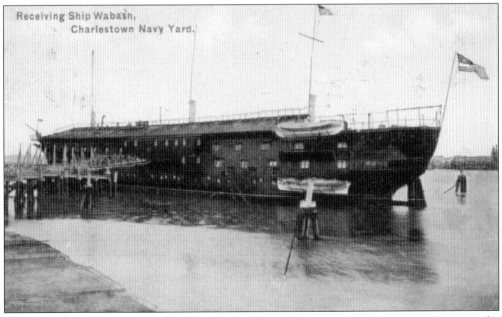

Receiving Ship Wabash,
Charlestown Navy Yard.

The USS *Wabash* was launched in Philadelphia in 1855. In the Civil War, it took part in the blockade of the Confederacy's Atlantic coast. It captured several ships and participated in securing sections of the South Carolina coast. From 1876 to 1912, the *Wabash* was the receiving ship at the Charlestown Navy Yard.

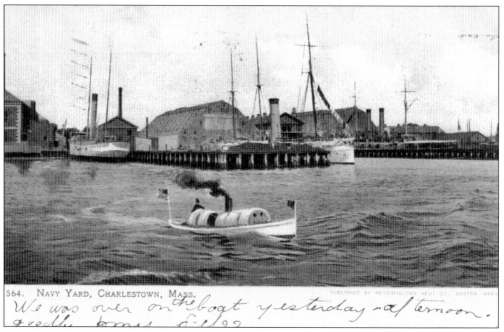

The publisher of this postcard most likely added the navy launch in the foreground. The view shows the main buildings of the navy yard. On the left at the edge is the machine shop and the ship houses are to the center and on the right. There is not much activity in this section of the yard in this pre–World War I postcard.

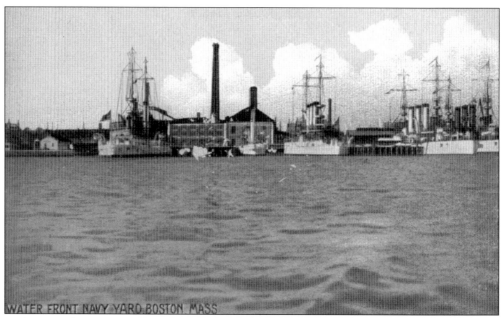

A chimney that was over 239 feet tall was built in 1857 for the machine shop, which is just left of center in this view. The chimney was a signature on the navy yard's skyline until it was taken down in 1903. There are four battleships in this view that were called to action in World War I.

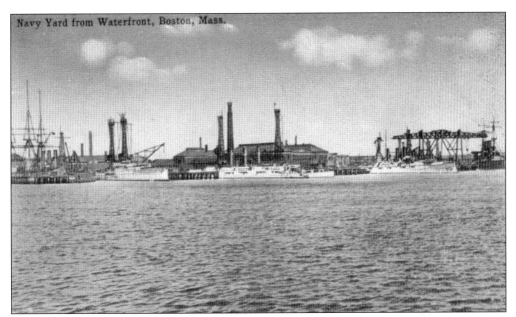

Before World War I, most of the Navy's battleships were on the East Coast. Battleships came to the Charlestown Navy Yard for assignment or repair. The ships with the "basket masts" in this postcard are battleships of the Atlantic Fleet.

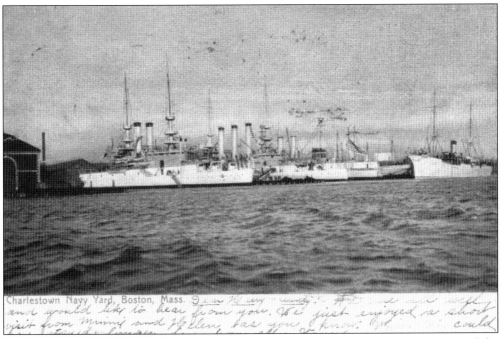

This is another view of the battleships lined up at the navy yard docks. The U.S. Navy and the people of Boston had a good relationship. The yard put many Bostonians and Greater Bostonians to work until 1974 when it finally closed.

Dry Dock 2 was opened in 1904. It was 729 feet long and could accommodate all the ships of the fleet. The cruiser *Maryland* was the first ship to use the new dry dock.

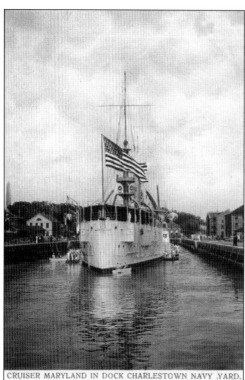

CRUISER MARYLAND IN DOCK CHARLESTOWN NAVY YARD.

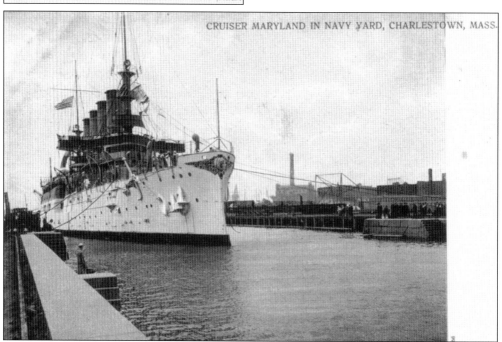

CRUISER MARYLAND IN NAVY YARD, CHARLESTOWN, MASS.

It is a grand day for the new Dry Dock 2 in this image. There are garlands on the ship, on the dock, and even in the water of the dry dock. The armored cruiser *Maryland* (ACR–8), shown here, was launched in Newport News, Virginia, in 1903. It was renamed the USS *Frederick* in 1917. It served in World War I and was stricken from the U.S. Navy lists and sold in 1930.

Ten

FROM WINTHROP
TO NAHANT

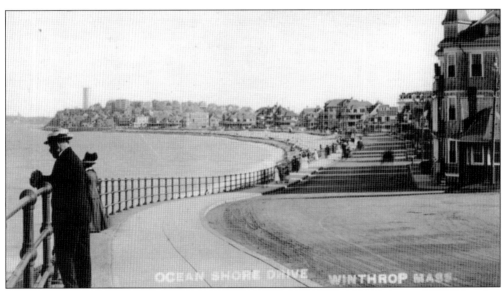

Somehow, the city of Boston is a cultural divide for the people of the communities north and south of Boston. One woman, early 20th century *Hull Beacon* editor Floretta Vining, categorized the competitive nature of the relationship between the regions when she commented that the city of Revere had been named for a man who took a very fast ride, Paul Revere, of the famed midnight ride during the American Revolution; therefore, she continued, it should come as no surprise that the place might be a bit racy in spots. Wherever the rivalry came from, one thing is for certain, loyalties and allegiances to the towns north and south of Boston, whether as year-round or vacation homes, remain as firm and strong as they have ever been. And who could blame the people of Winthrop, Revere, Lynn, and Nahant for loving what they have? Here, Winthrop Shore Boulevard winds off toward the south and into Boston Harbor.

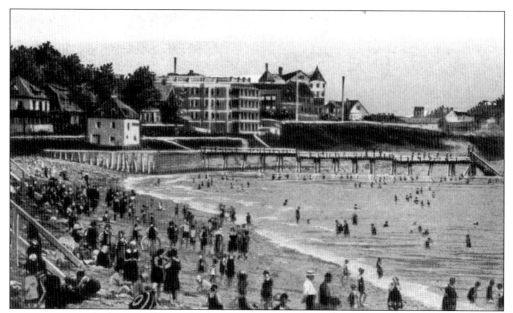

Just over that railing laid the gold that every summer treasure hunter was looking for, sand and surf. Winthrop Beach experienced the same waxing and waning periods as did other Boston Harbor beaches, reaching heights of popularity in the steamboat/train era of the late 1800s, yet succumbing to the power of the wanderlust of the American people when the automobile rumbled onto the scene.

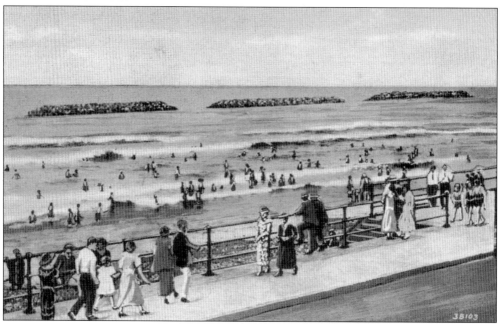

The Winthrop Beach shoreline has been protected by man-made elements since 1899, when the first seawall was constructed. A major winter storm caused considerable damage here in December 1909. As further protection from the inroads of the sea, five offshore breakwaters known as the "Five Sisters" were constructed from 1933 to 1935. Erosion of the beach continues to be a focus of study and concern for the people of Winthrop and the Massachusetts state government.

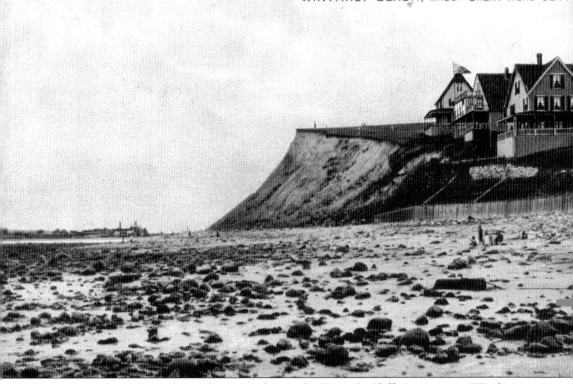

Great Head splits the Winthrop shore. To the north, Grover's Cliff gives way to Winthrop Beach and Winthrop Shore Drive, which culminate at Great Head, the highest point in the community. To the south of Great Head, a sandy spit reaches away to Point Shirley, at that time of this postcard it was separated from Deer Island by Shirley Gut, which has since been filled. Promontories like Great Head naturally drew tourists, and therefore developers. One hotel man, Philip Yeaton, known for his strong personality (his obituary claimed that when he worked at a hospital in Augusta, Maine, he could "control a room full of insane men by his presence"), operated the Great Head House there for several summers. Today, the hill is simple to pick out from many points on Boston Harbor, signified by the red, white, and blue water tower that was constructed in 1910.

That long stretch of Winthrop Beach, of course, also called to hoteliers and other entrepreneurs. And it called to the rich and famous. Author Mary Maclane stayed here in October 1902, shortly after the publication of her autobiography, *The Story of Mary Maclane*, shook the country. For defying the puritanical restraints of the day in her tell-all book, Maclane is known as the first "New Woman," and possibly the first flapper. Her book sold 100,000 copies in the first month after its release.

The back of this postcard of the Boulevard Hotel states that the view from the windows of this establishment on the beach showcased the Atlantic Ocean, "with Nahant, the islands of Boston harbor, also Hull, Pemberton and Nantasket plainly visible to the naked eye." It also espoused the concept of a working vacation, stating that with trains running every 10 minutes to Boston, "this affords the business man opportunity of transacting his affairs during the day and at the same time enjoying his mornings and evenings at the beach."

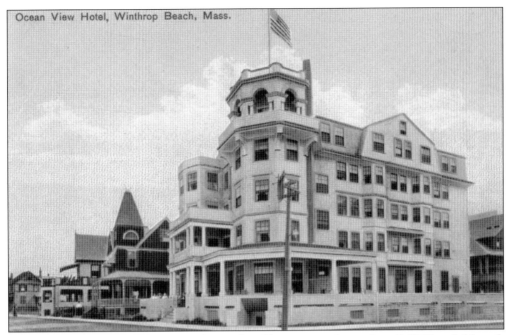

Ocean View Hotel, Winthrop Beach, Mass.

The Boston, Winthrop and Point Shirley Railroad began operation on June 7, 1877, and although changes of ownership and routes came over the years, the fact that the trains were running to the Winthrop shore meant that money was to be made. Hotels sprung up as early as 1882, until more than 60 covered the town, including the Ocean View, shown here.

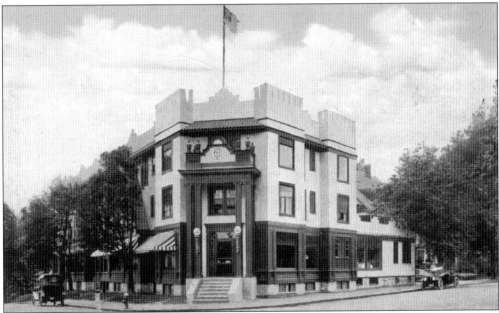

High atop Grover's Cliff on Grover's Avenue sat the Winthrop Arms, just a stone's throw from the Cliff House, another of Winthrop's fabulous hotels of the early 20th century. Although modified since its 1916 opening, the Winthrop Arms survives today. Then famous for its 15,000-foot putting green and ballroom, the Winthrop Arms today is known for its restored mahogany lobby, a piece of old Winthrop kept alive by its new owners.

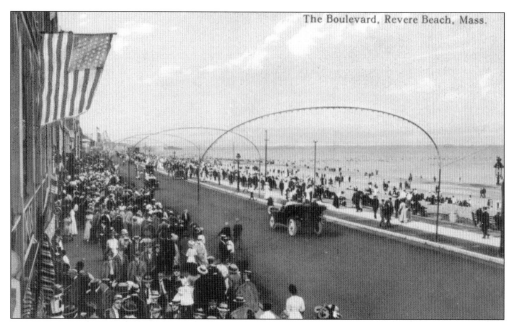

Revere, or prior to 1871, North Chelsea, had already been discovered as a getaway point before the trains of the Boston, Revere Beach and Lynn Railroad arrived in 1875, but the steam engine's whistle truly signaled the beginning of the community's growth. As with Winthrop, the lure of the refreshing ocean waters drew thousands to Revere Beach during the last quarter of the 19th century.

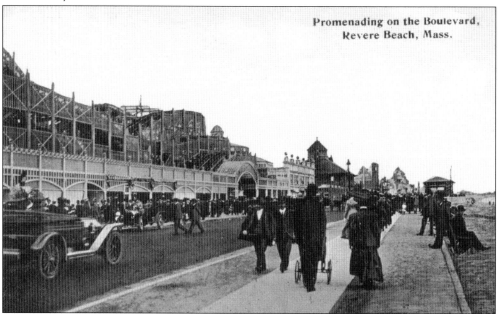

Promenading on the Boulevard,
Revere Beach, Mass.

Revere Beach was the first public American beach, a project of the Metropolitan Park Commission (now part of the Massachusetts Department of Conservation and Recreation). The day that Revere Beach Reservation opened, July 12, 1896, an estimated 45,000 beachgoers set their sights on the sands that day. Five times that many could be seen on the beach on any given hot day in summer.

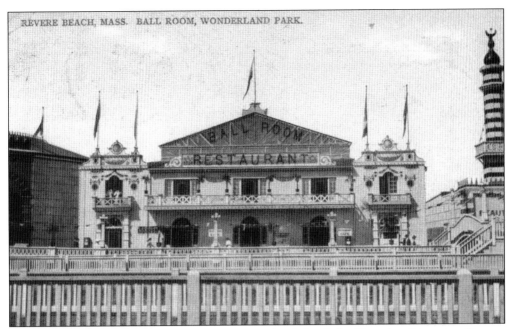

Wonderland opened in 1906 and closed in 1911, but it has left a lingering impact on Revere history. The amusement park featured a show called *Fighting the Flames* that boasted a cast of 350 people, allowing 3,500 visitors (who had paid a dime each to enter the park) to watch the drama of a city block engulfed in flames saved from destruction by a ladder crew. Like any good Coney Island–style park of its day, Wonderland had its own ballroom.

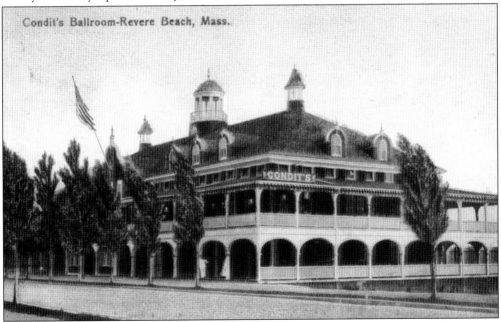

Condit's Ballroom-Revere Beach, Mass.

Like many establishments of the day, Condit's Ballroom, built in 1904 at Eliot's Circle at the beginning of Revere Beach, went through several name changes as owners came and went. At one point it bore the name Spanish Gables, and finally, after World War II, it became known as the Oceanview Ballroom, until it was destroyed by fire in December 1959.

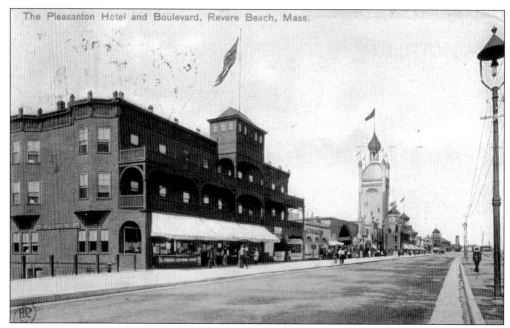

The Pleasanton Hotel was just one of many of its type of attraction along Revere Beach. The boulevard offered all sorts of diversions for those folks looking to get away from their regular routine, from movie theaters to dance halls and more. The arabesque tower in the background is the entrance to the Nautical Gardens ballroom.

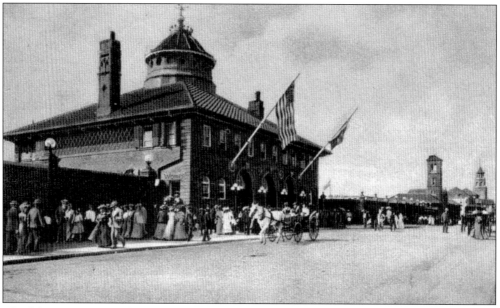

The debate concerning the creation and design of Revere Beach Reservation centered on several themes, including moving the Narrow Gauge railroad off the crest of the beach itself and the need for basic beach amenities, such as a well-appointed bath house, shown here. Landscape designer Charles Eliot, father of Massachusetts's state park system, fought for the relocation of the train and won, allowing a clear path for his vision of the reservation's future.

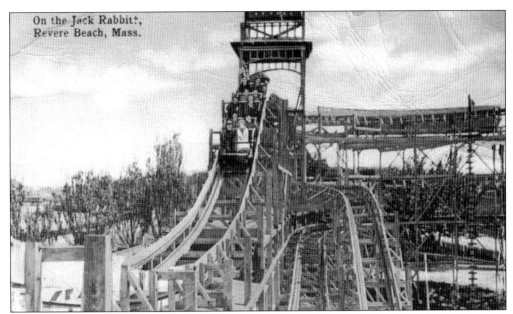

The Jack Rabbit was one of those rides known simply as a shoreside amusement of Revere Beach, a park ride operated independently of any park. Other such rides included carousels, fun houses, the fast and thrill-a-minute Cyclone coaster, and the popular Chute the Chutes rides found in several places along the coast. This coaster was located at approximately number 50 on Revere Beach Boulevard.

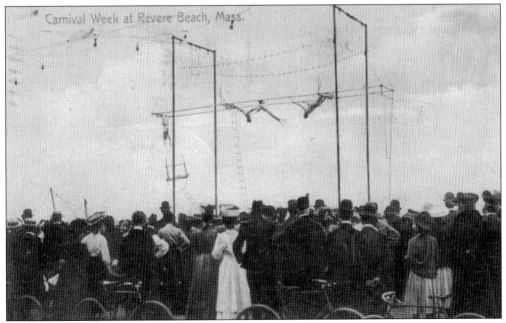

Although it would seem that every day was just such a celebration in places like Revere, seaside communities regularly stepped up their crowd-luring activities with specially designated days or weeks that featured shows and attractions not offered on regular days on the summer calendar. Revere Beach featured Carnival Days, which in 1906 featured a huge papier-mache volcano called the "Electric Mountain."

Farther up the coast, Lynn Shore Drive opened in 1910. In between the time of the founding of the Lynn Yacht Club in 1870 and the opening of the roadway, the city had become a center of technological development. In 1892, Edison General Electric Company and the Thomson-Houston Electric Company merged to form today's General Electric.

The exigencies of the sea inspire many people every day, but it takes a special gathering of artistic minds to create something as wonderful as the Lynn Beach Painters did between 1880 and 1920. Lynn Beach, complete with its own state operated bath house, shown here, was a typical destination for its day, an escape from what was not that long ago the largest shoe manufacturing city in the world. Today one can almost see the beach as it was by visiting the Lynn Museum and asking to see the collection of more than 50 paintings completed during this period.

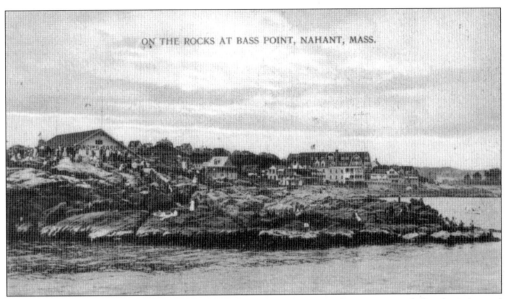

Rocky Nahant was already a destination of choice by 1823 when Boston philanthropist and China trade merchant Thomas Handasyd Perkins built his hotel there. Perhaps because of this fact, the community was ahead of the curve as far as permanent settlement growth went. While other communities such as Nantasket remained small (with fewer than 500 year-round residents as late as 1890), Nahant had already attracted many visitors that chose to ultimately build homes along the shore.

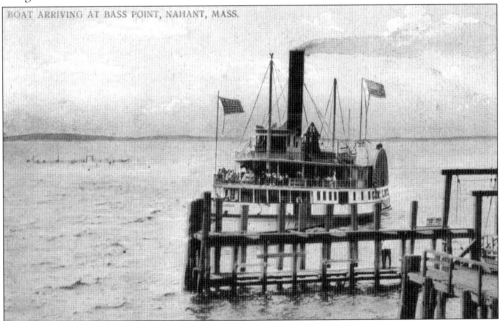

BOAT ARRIVING AT BASS POINT, NAHANT, MASS.

Steamboat service to Nahant started in 1817 with daily trips to Boston. "Where in the world is there such a delightful dormitory as Nahant," wrote Robert Grant in *Scribner's Magazine* in July 1884, "distant by either sea of land only an hour from the city, where the tired business man may refresh his brow and lungs and eyes, and his children may breathe ozone day in and day out, and learn to swim like ducks in the coldest of cold waters?"

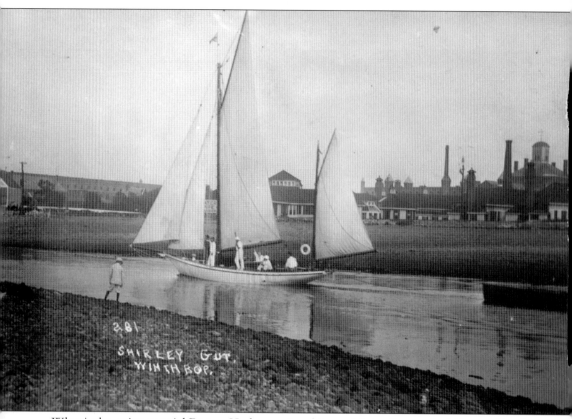

What is the quintessential Boston Harbor postcard image? Is it a jam-packed Revere Beach on a July afternoon, or solitary Boston Lighthouse with its sweeping rays of light cutting through the darkness? Or is it a view of the Charleston Navy Yard, with the USS *Constitution* in the foreground and the Bunker Hill Monument in the background? Or is the Boston Harbor of old best exemplified by what no longer exists, like Shirley Gut? The fact is that Boston Harbor has meant many things to many people, before and after the invention of the postcard, and millions have been entertained by its natural and man-made attractions through relaxation, excitement, and innocent joyous wonder. The harbor, from Nantasket to Nahant and every point in between, still beckons. Boats of all kinds pass in and out of coves, river mouths, and bays; yachtsmen test their skills against one another as their great-grandparents did; and, although they have been tamed by time, amusements still call the thrill-seekers on the sandy beaches all around the harbor. While the physical realities of the Boston Harbor communities continue to evolve, the spirit of the Boston Harbor of the postcard era lives on.

ACKNOWLEDGMENTS

The authors ranged far and wide to find the best selection of postcards depicting the many themes of Boston Harbor, its islands, boats, and people, and everywhere we went we were greeted with smiles, offers for beverages, and provocative conversation. On many occasions, we found answers to questions we did not even know to ask in the first place. We learned something new at each stop along the way, from Hull to Nahant, from people we had met literally minutes before, but who were thoroughly passionate about their postcard collections and the history of their communities.

In no particular order, we would like to thank the following individuals and organizations: William and Elaine Pepe of Weymouth; Philip G. Hunt, museum specialist for the National Park Service's Boston National Historical Park; John Tramontana of Whitman; G. David Hubbard and Stephen F. Moran and the Winthrop Improvement and Historical Association; the staff of the Chelsea Public Library; Henry Day, Nancy Tiffin, and Valerie A. Thomas for aid with postcards from the collection of the Hingham Historical Society; Rodney Brunsell of Hanson; Earl Taylor of Dorchester; Jeanne Holland of Rockland; Joan G. Noble of the Quarterdeck in Scituate; Carole Mooney of Dorchester; the Boston Harbor Island Alliance; James E. Fahey, director of the Watson Museum and Research Center, a branch of the Braintree Historical Society; Linda Beeler and the reference staff of the Thomas Crane Public Library in Quincy; the Hull Historical Society; the Fort Revere Park and Preservation Society; Elizabeth Murphy and the reference staff of the Tufts Library in Weymouth; the Historical Society of Old Abington; the staff of Abington's Dyer Memorial Library; architectural historian Wick York of Stonington, Connecticut; lighthouse and lightship historian Doug Bingham of Taunton; Bob Trapani, executive director of the American Lighthouse Foundation; John Forbes of the Friends of Boston Harbor Islands; Harold "Bumper" Gooding of Nahant; historian Fred Hills of Hingham; Ed Cohen of Hull; Bruce Berman of Save the Harbor, Save the Bay; and Ed Fitzgerald and the staff and volunteers of the Quincy Historical Society.

Donald Cann would like to thank his wife Janet Cann and his brother James S. Cann, and John Galluzzo would like to thank his new wife, Michelle, for sailing through a sea of postcards for the past several months.

Support Your Local Historical Societies

The authors encourage one and all to patronize the organizations that helped make this book possible, and, when the time comes, to consider donating your postcard collections to them so that history may be enjoyed by all future generations of the Boston Harbor communities. Please contact them at the addresses below.

Boston National Historical Park, Charleston Navy Yard, Boston, MA 02129
Braintree Historical Society, 786 Washington Street, Braintree, MA 02184
Chelsea Public Library, 569 Broadway, Chelsea, MA 02150
Dorchester Historical Society, 195 Boston Street, Dorchester, MA 02125
Dyer Memorial Library, 28 Centre Avenue, Abington, MA 02351
Fort Revere Park and Preservation Society, PO Box 963, Hull, MA 02045
Hingham Historical Society, PO Box 434, Hingham, MA 02043
Historical Society of Old Abington, 28 Centre Avenue, Abington, MA 02351
Hull Historical Society, 253 Atlantic Avenue, Hull, MA 02045
Quincy Historical Society, 8 Adams Street, Quincy, MA 02169
Thomas Crane Public Library, 40 Washington Street, Quincy, MA 02169
Tufts Library, 46 Broad Street, Weymouth, MA 02188
Winthrop Improvement and Historical Association, 40 Shirley Street, Winthrop, MA 02152